Collins

Elizabeth Conlon

First published in 1995 by Collins, an imprint of
HarperCollins*Publishers*
77-85 Fulham Palace Road
Hammersmith
London W6 8JB

The Collins website address is www.**collins**.co.uk

Collins is a registered trademark of HarperCollins Publishers Ltd.

06 08 10 09 07 05
2 4 6 5 3 1

© Elizabeth Conlon 1995

A catalogue record for this book is available from the British Library

Editor: Geraldine Christy
Art Editor: Caroline Hill
Designer: Amzie Viladot
Photographer: Jon Bouchier

ISBN 0 00 719911 2

Printed and bound by Printing Express, Hong Kong

Previous page: **Alcea rosea**
25 x 24 cm (10 x 9½ in)

This page: **Magnolia grandiflora**
19 x 24 cm (7½ x 9½ in)

Opposite page: **Odontioda 'Vaila'**
23 x 32 cm (9 x 12½ in)

CONTENTS

PORTRAIT OF AN ARTIST

ELIZABETH CONLON

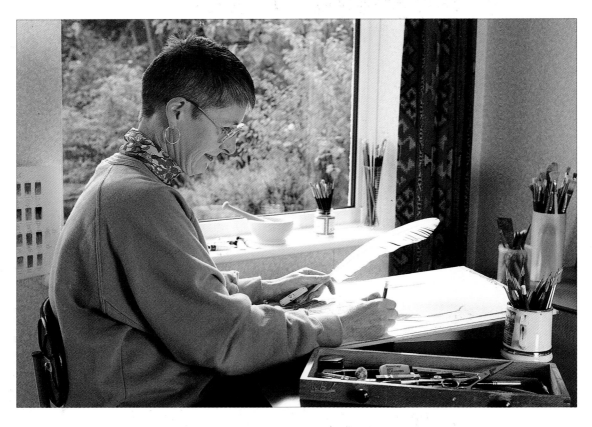

▲ *Elizabeth Conlon at work*

Elizabeth was born in Dublin and has lived in Dorset since 1966. Her present home and studio are situated on the edge of Poole Harbour, a beautiful natural expanse of sheltered water and islands, of which the most well known is Brownsea Island, a nature reserve. Her family shares an enthusiasm for the sea and small boat sailing.

After studying at the Central School of Art in London, Elizabeth had a complete break from painting to care for her two children and help run the family business. Since taking up painting again she has experimented with various media and techniques, including watercolour, oil, egg tempera, miniature painting and a variety of subjects. She is currently producing detailed botanical drawings, still-life oil studies and semi-abstracts based on her botanical studies and including life drawings of the human figure.

In her schooldays Elizabeth always enjoyed painting flowers, but she first began to take a serious interest in botanical illustration and flower portraiture when she found that the time she was able to set aside to follow her artistic interests, such as painting

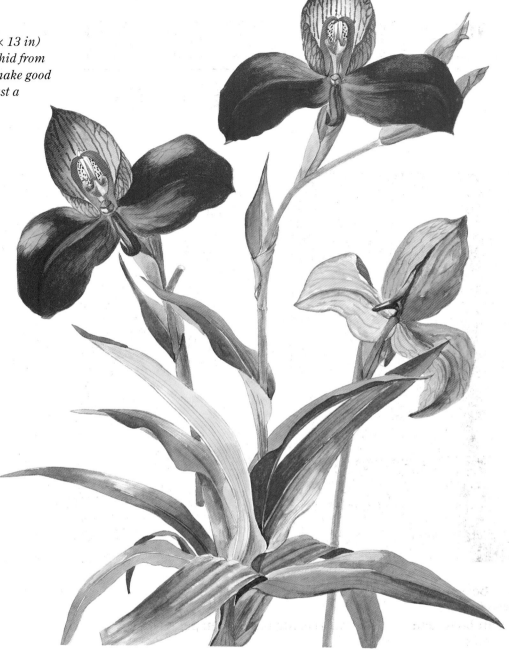

▶ Disa
24 × 33 cm (9½ × 13 in)
A vibrant red orchid from
Africa. Orchids make good
subjects as they last a
long time.

on location, was severely restricted by business and family commitments. The simple answer to such constraints of time and place was to concentrate on plants and cut flowers, subjects that present an opportunity to draw and paint from life rather than from sketchbook or photographs.

Portraying flowers also means that a piece of work can usually be finished in the time intended,

but it can also be put down and resumed the next day, or week, if need be. There are exceptions, of course, and individual plants present their own demands.

Obtaining specimens of rare or unusual plants to study and paint is difficult. Elizabeth keeps a keen ear open to glean new sources of material and finds that nurserymen and growers are often quite happy to lend her some of their precious plants.

Elizabeth is a member of the Society of Botanical Artists, who hold their Annual Exhibition at Westminster Central Hall, Parliament Square, London, each spring. She has had three one-person exhibitions and is a regular exhibitor at the Mall Galleries, London, with the Royal Society of Marine Artists, the Royal Institute of Oil Painters and the Royal Institute of Painters in Water Colours.

PORTRAYING FLOWERS

Many people have the compulsion to draw and paint, but may need convincing that they can tackle flowers as subjects. A brief glance at any book containing plates of wonderfully detailed plants or flowers may make you feel that creating something similar is an impossible goal. Such work, however, is chiefly based on acquired skill. Let me assure you that application and determination will overcome any faintheartedness and that anyone can learn to produce a picture of which to be proud.

One of the great advantages of flower portraits is that you bring your subject into your own environment and tackle it on your own terms. The landscape painter is unable to enjoy such luxury. Within your own friendly conditions you can take your time to carefully decide where and how best to arrange the plant and settle down to work. There are few time constraints and you can slow down or stop work whenever you like.

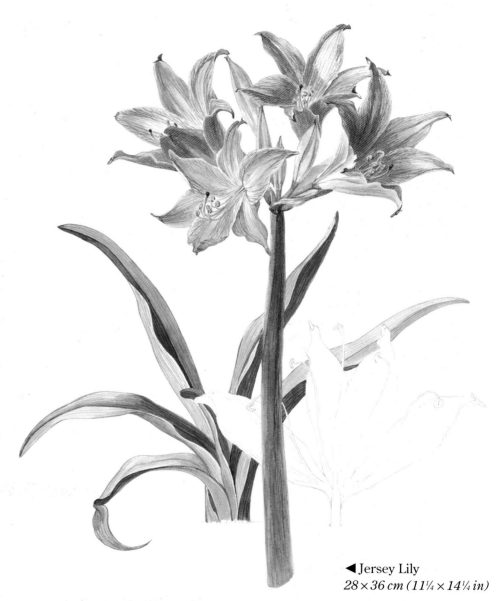

◄ Jersey Lily
28 × 36 cm (11¼ × 14¼ in)

BOTANICAL ILLUSTRATION

The term botanical illustration traditionally defines a piece of work with the prime *raison d'être* of fully describing a plant so that its true identity cannot be called into question. Herein lies its subtle distinction from flower painting, which may be botanically correct but where any amount of licence is allowed in decorative interpretation.

Botanical illustration requires accurate plant morphology. In the nineteenth century botanical artists were often practising scientists who drew and painted to make technical records of the plants they studied. They needed to portray all aspects of their subjects, adding diagrams and enlarged drawings of details. The drawings produced by these past masters are admired today as works of art in their own right.

FLOWER PORTRAITS

The correct, qualified approach of botanical illustration gives authority to flower painting, without necessarily portraying every aspect of the plant that would be essential for that type of technical recording. In flower painting you may choose to limit your work to only those aspects that you find particularly appealing and contribute to creating a beautiful artefact.

I often leave part of my flower portraits as line drawings, with or without further detail or shading. I think this helps create the illusion of what is generally thought of as traditional botanical illustration, yet makes a clear distinction between this genre and flower painting. I find it best to draw and paint the flowers to as advanced a stage as possible during the first session, and to leave starting work on the rest of the picture, other than to roughly sketch in the placement of elements such as leaves and buds, until the next day when they may well have completely changed their posture.

REFERENCE SOURCES

Arm yourself with a simple botanical textbook. If you have a particular area of interest, such as wild flowers, garden hybrids, fungi etc., obtain a good flora covering that subject. You can avoid many problems if you know what you are looking for, what is essential to get right and what aspects you need to emphasize.

It is important that any labelling of your work is correct. If you are at all unsure of your ground, only label your drawing in very general terms.

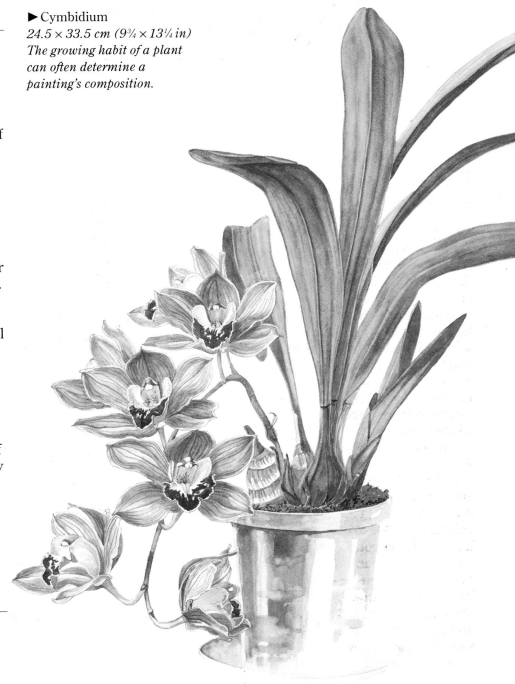

▶ Cymbidium
24.5 × 33.5 cm (9¾ × 13¼ in)
The growing habit of a plant can often determine a painting's composition.

INDIVIDUAL FLOWERS

Once you start painting you will soon observe that any flower you care to study will not conform to any pictorial interpretation you can find. Each species has its distinct set of features within which each specimen can show considerable variation. To prove the point to yourself take an illustration that you admire, then just try to find a flower to match it. Any individual flower other than the one portrayed by the artist will differ in size or colour and will take up a different, albeit characteristic, posture.

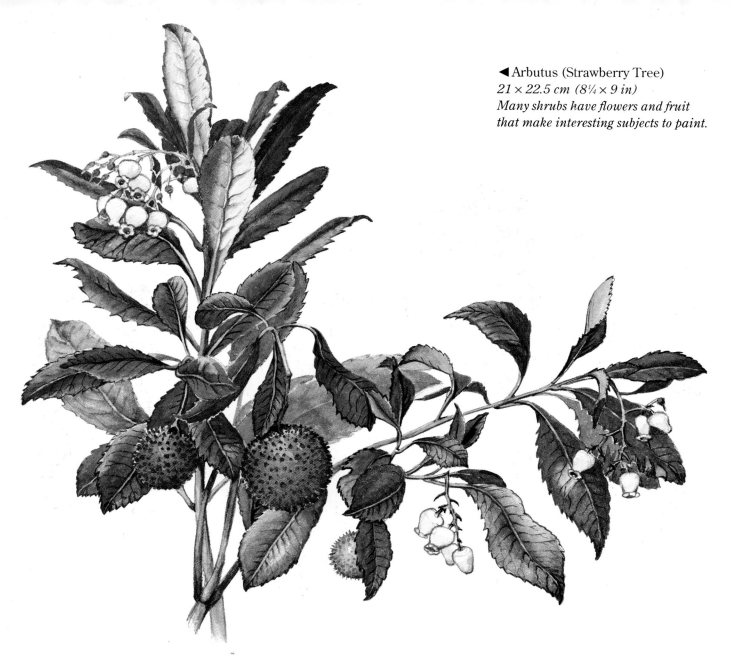

◀Arbutus (Strawberry Tree)
21 × 22.5 cm (8¼ × 9 in)
Many shrubs have flowers and fruit
that make interesting subjects to paint.

When you have had a go at this disciplined approach to flower painting you may decide to pursue a much looser style. If so, first take a single flower from the ones you wish to paint and make an accurate drawing of it. This close observation will be instrumental in enabling you to produce a spontaneous picture.

FLOWERS IN THE STUDIO

When plants and cut flowers are brought indoors remember that they have been plucked from their own environment and introduced into one that is foreign to them. You will soon notice whether the flower opens quickly, or it may close up, or even wither. Other changes also take place more slowly. Flowers and leaves will turn on their axis so that their greatest surface areas face the new light source and may even bend their stems in that direction.

There are many advantages in using a potted plant as your subject. Cut flowers often fade too quickly for use after only a few days, but most varieties of potted plants bloom for several weeks, so you can take your time. Turn the plant around to discover its best side, and do not be afraid of a little judicious pruning – the removal of a few leaves can often improve the overall look from an artist's point of view. Try to reveal a small section of the pot's rim to give the picture credibility.

You can use one view for a particularly lovely flower and then turn the pot around to complete the composition if the

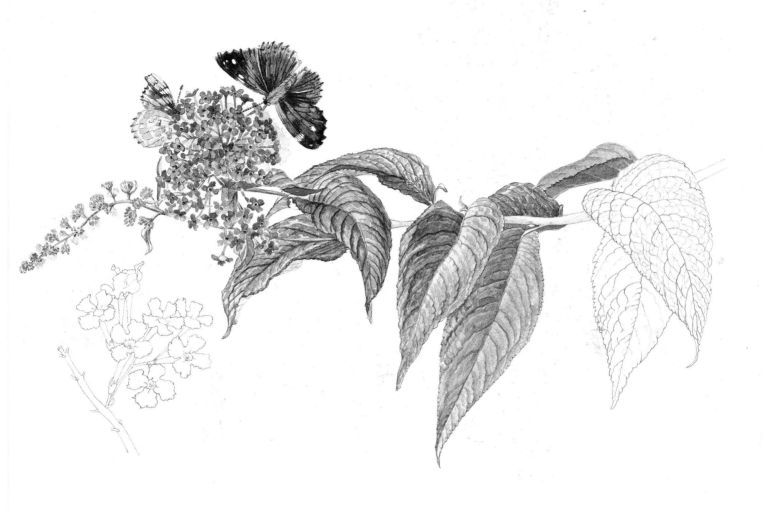

rest of the plant or flowers look more attractive from another vantage point.

If you wish to down tools for a few days and find the first flowers have faded on your potted plant, other similar ones will soon replace them and with a little imagination they can be used to finish the picture.

Start a collection of colourful old plates and saucers upon which to stand pots so that you can choose one that is sympathetic to a particular plant to enhance your composition.

Compose your subject as soon as possible and place the potted plant or the cut flowers in water in the place where they will stay while you paint your picture. Do this a couple of hours ahead of each proposed working session. Flowers and plants can change their orientation out of all recognition, particularly if the room is warm and there is a bright window.

▲ Buddleia
22 × 35.5 cm (8¾ × 14 in)
These flowers are a favourite with Red Admiral butterflies.

FLOWER AND LEAF STRUCTURE

If you want to draw and paint flower portraits that will carry conviction you will find that it is helpful to have a fundamental knowledge of the structure of flowers and leaves.

THE PLANT KINGDOM

Flowering plants belong to the most advanced group of plants and are the dominant plants in the world today. They display great variation in form, ranging from simple stemless plants such as free-floating duckweed to giant forest trees.

 The flowers contain the reproductive parts of the plant and are where the seeds are produced.

PARTS OF A FLOWER

A typical flower consists of four distinct parts. The calyx comprises the sepals – these small, usually green, leaf-like petals protect the flower while it is in the bud stage. The corolla comprises the petals, which are usually coloured to attract insects to the flower to assist in its pollination. The androecium comprises the stamens, the male pollen-carrying parts of the flower consisting of anthers and filaments. The gynaecium comprises the pistil or carpel, which consists of the stigma, at the top of the style, where pollen

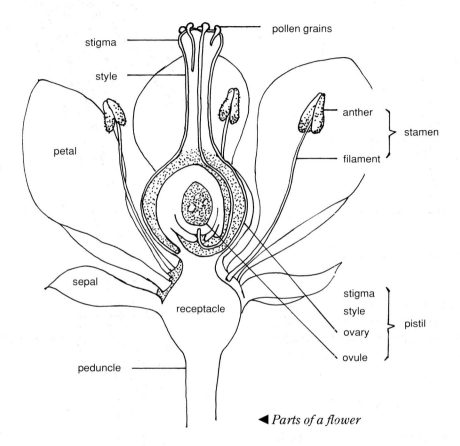

◀ *Parts of a flower*

grains from another flower are deposited, and the ovary and ovules – all form the female part of the flower.

 All four main parts of the flower are borne on the receptacle at the top of the stalk.

COMPOSITE FLOWERS
The largest group of flowering plants is the Compositae family, which includes plants with daisy-like flowers. When you first look at a composite flower it appears to have numerous densely packed petals, but closer examination will reveal that it is

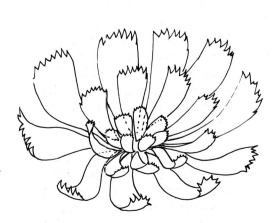

▲ *A composite flower made up of many single flowers (florets)*

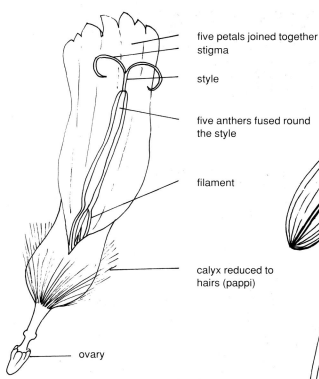

five petals joined together
stigma

style

five anthers fused round
the style

filament

calyx reduced to
hairs (pappi)

ovary

▲ *A single dandelion floret*

Tip

● A brief examination under a magnifying glass will help you make better sense of a flower's structure.

made up of many tiny complete flowers, or florets. A composite flower may contain only male or female flowers, or some of both.

PARTS OF A LEAF

Flowering plants are divided into two groups, according to the structure of their leaves.

Monocotyledons, such as lilies, have one specialized leaf or cotyledon within the seed swollen with food reserves. The leaves are narrow, with parallel venation. The flower parts are usually in groups of three.

Dicotyledons, such as buttercups, have two cotyledons within the seed. The leaves are broad, with a network vein pattern, and flower parts are usually in groups of four or five. The stems become woody as they increase in diameter.

midrib

parallel small veins

▲ *Monocotyledon leaf*

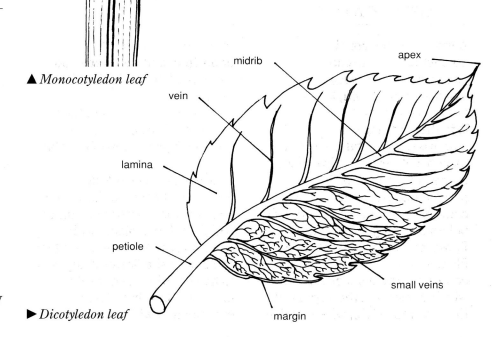

midrib

apex

vein

lamina

petiole

small veins

margin

▶ *Dicotyledon leaf*

MATERIALS AND EQUIPMENT

The cost of the basic materials needed for drawing and painting in watercolour is quite low as there are many reasonably priced good quality products from which to choose. Resist selecting top-of-the-range items until you are sure they will suit your individual requirements.

PAINTS

Watercolour paint consists of pigments which have been ground and mixed with varying amounts of chalk – the more chalk the cheaper and more opaque the colour. The mixture is then bound together with gum arabic, and sometimes a little honey to give it a long usable life. The paint is then either put into tubes or made into cakes that fit into tiny pans that in turn will fit neatly into paintboxes.

Whether you choose pans or tubes of paint is a matter of personal preference, but pans are easier to manage out of doors. Tubes of paint can be extravagant and time consuming for flower portraits. Most of the time you will only need small touches of colour with which to make minor adjustments to hues and tones.

PAINTBOXES
Most paintboxes are made from enamelled pressed-out steel sheet. Some are made from moulded plastic but they tend to stain easily. Boxes are sold with a pre-selection of popular colours or empty so that you can build up your own range over time. An empty box or palette, with compartments that will take whole or half-pans, or can be filled from tubes, is a convenient method of storage and for handling in use.

Purchase whole pans of colours you will use most, or are cheap, and only half-pans of expensive paints or those that you rarely use.

CHOOSING COLOURS
The cheaper Students' Colours seldom match the superior texture and tinting power of Artists' Colours, which vary in price from colour to colour, and it

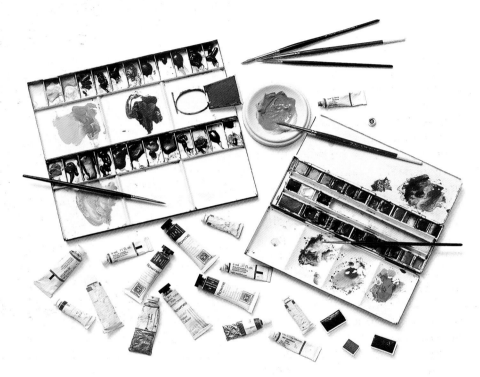

▲ *The author's paintboxes with pans and tube colours arranged in the same order as on her colour chart (see page 19)*

is usually more economical to purchase Artists' Colours.

A small range of colours to start you off might be: Lemon Yellow, Cadmium Yellow, Cadmium Red, Crimson, Cobalt Blue, French Ultramarine Blue, Sap Green.

BRUSHES

There are no substitutes for Kolinsky sable-haired brushes; they are firm and springy to handle. The Daler-Rowney 'Diana' range and Series 7 brushes may both be relied upon for consistent quality. Some brush-makers use longer hairs which hold more water and pigment. These brushes are also more supple in their handling, which is more akin to drawing with a lead pencil, and they are useful for adding detail.

The Daler-Rowney 'Dalon' range of synthetic-haired brushes is excellent value, though they do not hold quite as much water as sable and are not as proficient at lifting out. They are ideal for beginners, however, or anyone undecided on which particular sizes to settle for.

Squirrel-haired brushes are much softer, but many painters find them difficult to control.

Buy three brushes at first, roughly sizes 0, 3 and 5. Try them out in the shop with water to see if they form good points – dip the brush well into the water and then shake it vigorously.

PENCILS

Lead pencils are graded from very soft 6B through to extremely hard FF. Each grade has a distinctive quality of line.

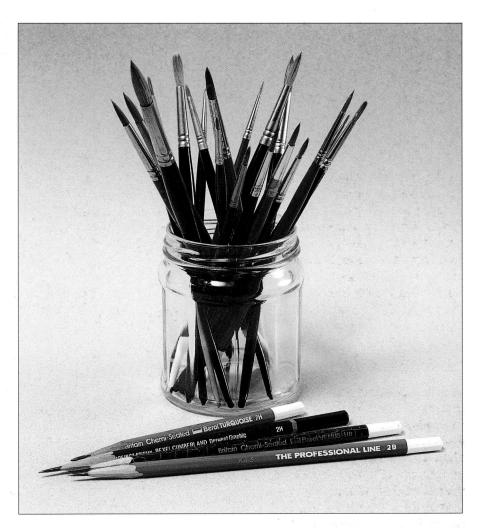

You will need at least one each of 2B, HB, 2H and 7H grades. The 2H grade is used for most of the lines that will remain on the finished work.

Well-sharpened points give clean lines, and long points to your pencils will render them usable for longer than those with short points. Pare down the wood about 2.5 cm (1 in) from the end, exposing 6–12 mm (¼–½ in) of the lead. Continue taking small cuts until you have a long needle-fine point. Smooth away any roughness on scrap paper.

Your 7H pencil will be used for pressing through, so must have a very fine point. Beware, however – it will instantly make a deep groove in any surface.

▲ *Kolinsky sable and synthetic brushes ready for use, and a selection of 2B, HB, 2H and 7H pencils*

▶ *HP paper is excellent for fine drawing, but it is difficult to apply an even wash on its smooth surface.*

▼ *Not paper takes washes well and allows the paint to flow freely. Here, red has been applied over a yellow wash.*

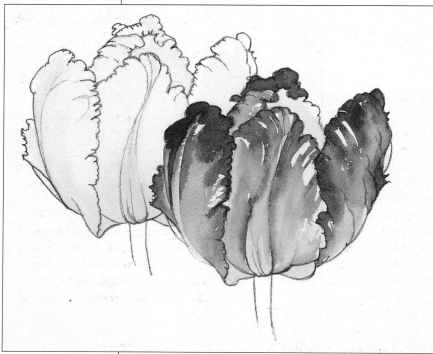

▶ *Rough paper has a rough texture which allows white paper to show through as highlights. Its use is limited for flower portraits, but effects can be achieved rapidly.*

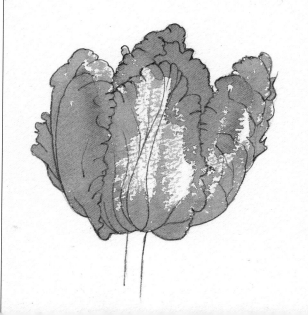

There is a wide choice of papers, but it is economical to limit your stock to two or three types.

DRAWING PAPER
Layout paper serves most purposes very well. This is a highly polished, thin but very strong paper, similar to bank and typing copy paper. One pad size A2 (24 × 16 in) of 50 gsm weight paper is an economic purchase as the sheets can be cut down.

Layout paper is designed for pencil drawing, but it also accepts pen and ink, coloured pencils and coloured markers. It will even take dryish watercolour washes, making it suitable for outdoor sketching. It is cheap enough to use as protection sheets for work in progress and for placing between pictures during transit and storage.

WATERCOLOUR PAPER
Most artists' materials suppliers offer a choice of several brand names. Usually lightweight ones and those made from synthetic materials are much cheaper than heavyweight handmade sheets made from cotton or linen rags and natural resins.

Papers are differentiated by their surface finish and texture. HP (Hot Pressed) is smooth and slightly shiny. NOT (Not Hot Pressed) has a matt finish. ROUGH papers have a rough finish, some of which are quite coarse grained.

The thickness of paper is classified by its weight in pounds or grams per square metre (gsm). Generally it is preferable to stretch any paper under 290 gsm (140 lb) before it is used, but not essential for the small areas of wash used in flower portraits.

WHICH IS THE RIGHT SIDE?

Nearly all paper has a right and a wrong side. Almost always (except in the case of 'Arches' paper) this may be determined by checking that the watermark is facing you.

CHOOSING A PAPER

There is no doubt that it is much easier to obtain good results from washes applied to Not and Rough papers, but for any detailed pencil drawing my advice is to persevere with painting on HP paper because it is much easier to sustain fine lines and to keep the whole composition clean.

Although HP paper is ideal for drawing it will take paint better if stretched. Submerse it in water to dissolve the size and soften the surface, then tape the edges to a board with gummed paper and allow to dry.

I find the most versatile, readily available and good value is the 'Saunders Waterford' range of mould-made papers manufactured from cotton linter and gelatine size. I consider their more rigid 300 gsm (140 lb) HP and 356 gsm (140 lb) Not papers the very best.

One of the most popular brands at the lower end of the market is 'Bockingford' 190 gsm (90 lb) and 300 gsm (140 lb). This is made from synthetic materials and it has some very good features. Its whiteness makes colours glow, it takes washes sympathetically and its surface is heavily sized, so although slightly rough any pencil drawing is not readily smudged or damaged.

What paper you choose to buy regularly will depend upon what features are the most important to you. Consider whether you prefer sheets or pads.

1

TRACING-DOWN PAPER

Tracing-down paper is used to press through outlines from carefully prepared studies onto watercolour paper. It acts in the same way as carbon, graphite and rouge papers, but its main advantage over any of them is that it makes a pencil lead image that will blend imperceptibly with any further drawing you may wish to make.

Take your time when making tracing-down paper. It will last for years and can be refurbished from time to time.

2

1 *Take an A3 (16 × 12 in) or one-half A2 sheet of layout paper. With an HB pencil closely cross-hatch evenly in one direction over the whole of one surface of the paper. Then cross-hatch at an angle of 90 degrees to the first.*

2 *With a crumpled piece of layout paper 'polish' the cross-hatching all over. This will prevent any loose lead dust making your work dirty. Keep your sheet of tracing-down paper folded in half, clean surface outwards.*

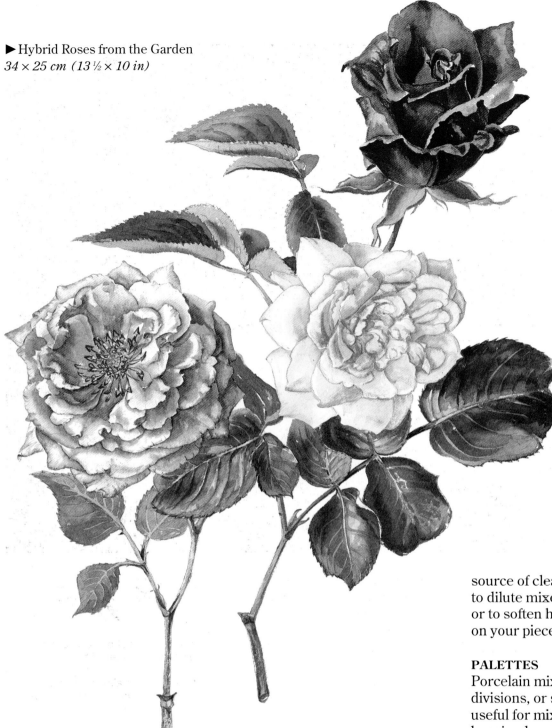

► Hybrid Roses from the Garden
34 × 25 cm (13 ½ × 10 in)

OTHER ESSENTIAL ITEMS

Make sure any necessary items are always to hand.

ERASER
Choose a large plastic eraser and cut a wedge of a convenient size. Re-cut its edges occasionally.

WATER CONTAINER
As a general rule a water jar cannot be too big. During painting sessions, before rinsing out the brush each time, first wipe it as clean as you can on the paint rag. In this way you will keep the water clean for very much longer, thus retaining a source of clear water with which to dilute mixes, to brush out with, or to soften hard edges of washes on your piece of work.

PALETTES
Porcelain mixing dishes, with divisions, or single saucers, are useful for mixing colours or for keeping larger quantities of a colour clean. If the mixture dries out it can be revitalized by adding clean water.

DRAWING BOARD
A piece of plywood 6 mm (¼ in) thick and about 45 × 60 cm (18 × 24 in) will make a good rigid drawing board. Check the wood for flatness and surface quality.

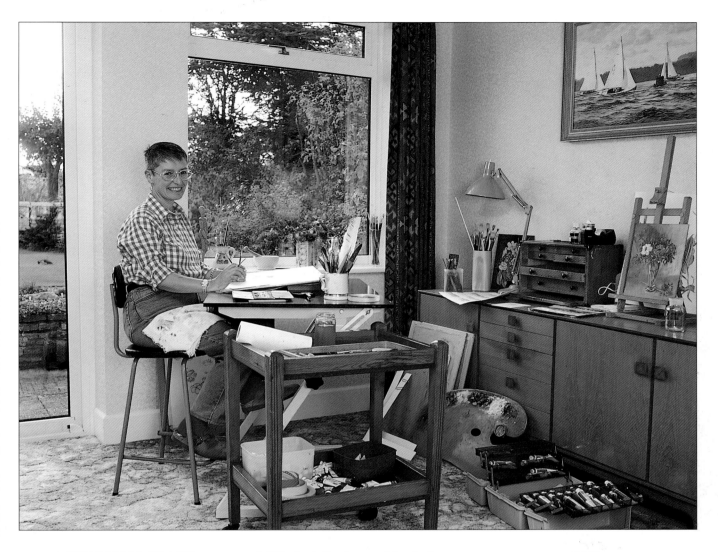

A PERSONAL SPACE

A studio is ideal, but this is not always possible. Where a room of your own is not available, at least annex a cupboard as a home for everything associated with your drawing and painting activities.

Be sure to have your working surface and chair at a comfortable height, with equal overall lighting. A daylight-adjusted strip light gives a good all-round illumination – switch it on as soon as the natural light begins to fade so that there will be no dramatic changeover. The light source should remain in a constant position until you have completed the piece of work.

▲ *Elizabeth Conlon working in her studio, where all her materials are kept close at hand*

● Keep at least one container full of clean water at hand.

● Keep your paintbox closed when not in use, or cover it with food film wrap.

● Store unopened pans and tubes in airtight containers or plastic bags.

● Free caps on tubes that have seized up by trickling very hot water over them.

● Tilt your drawing board by propping it up with an old telephone directory.

EXPLORING COLOUR

No pigment has the property of enabling the eye to perceive pure colour. When painting you need to explore many pigments, and sometimes mix them together to find colour matches that are as close as possible to the actual colours you wish to portray. When mixing paints and using them it is useful to have some idea of accepted colour theory and terms.

COLOUR MIXES

Primary colours or hues are the ones you cannot make by mixing other colours – red, yellow and blue. It is quite possible to paint a full colour representation of any object using only the three primary colours.

Secondary colours are created by mixing any two primary colours together – red and yellow make orange, yellow and blue make green, and blue and red make violet.

Intermediary colours are made by mixing a primary colour with a secondary one – for instance, red and orange make red-orange, and yellow and orange make yellow-orange. A different red in place of the primary red used to make the orange would create yet another version of the colour.

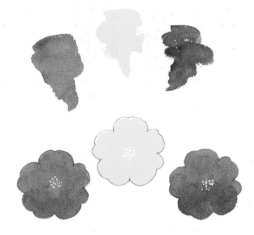

▲ *The three primary colours are red, yellow and blue. Here are Cadmium Red, Lemon Yellow and French Ultramarine.*

▲ *When two primaries are mixed together they form a secondary colour. Here Cadmium Red, Lemon Yellow and French Ultramarine are mixed.*

▲ *When an extra amount of one of the two primary colours is added to a secondary colour an intermediary colour is formed. Here, more Lemon Yellow has been added to orange to make yellow-orange, and Cadmium Red to orange to make red-orange. Other versions can be made by the introduction of different yellow and red pigments, such as Cadmium Yellow and Crimson Alizarin.*

COMPLEMENTARY COLOURS

Each primary colour has an 'opposite' or complementary colour which is the secondary colour made from the other two primaries – red is complementary to green, yellow to violet, and blue to orange. When complementary colours are used together they intensify the effect of each other.

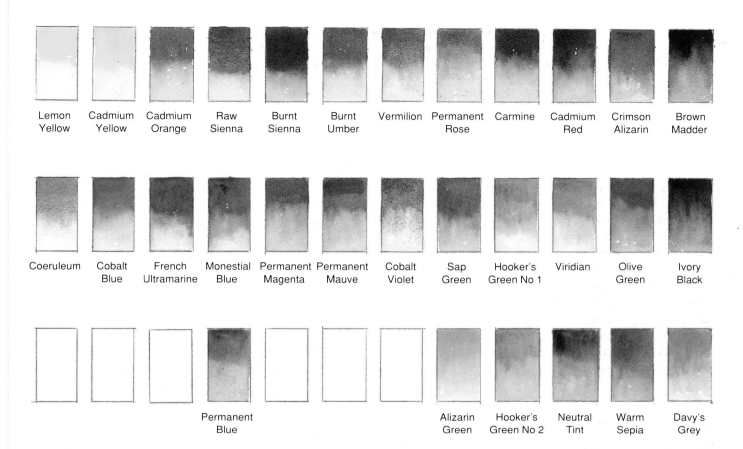

Lemon Yellow | Cadmium Yellow | Cadmium Orange | Raw Sienna | Burnt Sienna | Burnt Umber | Vermilion | Permanent Rose | Carmine | Cadmium Red | Crimson Alizarin | Brown Madder

Coeruleum | Cobalt Blue | French Ultramarine | Monestial Blue | Permanent Magenta | Permanent Mauve | Cobalt Violet | Sap Green | Hooker's Green No 1 | Viridian | Olive Green | Ivory Black

Permanent Blue | | | | Alizarin Green | Hooker's Green No 2 | Neutral Tint | Warm Sepia | Davy's Grey

COLOUR TEMPERATURE

The temperature of a colour is the scale of warmth given to our perception of colour. Reds, oranges and yellows are the warmest, while blues and greens are cooler colours. Slight modifications to a colour can often alter its temperature and make it more acceptable. For instance, if a green mixture appears too cool, or bluish, a touch of any warm colour, even a bright red, can make it seem less cold.

TONE

The tone of a colour describes its lightness or darkness, or the amount of shading it contains.

In flower painting the actual colour, or local colour, of the subject is of more concern than the tone of the colour.

A COLOUR CHART

A large colour chart kept permanently close to your painting area will help you decide which colour is the best one to use. It needs to be hung up in such a manner that it is readily taken down to be held as close as possible to the flower in question.

There are many advantages in settling on a fixed layout for the colours in your paintbox or palette and it is helpful to draw your colour chart to the same arrangement.

If, having made your chart, you decide that some of the colours are not to your liking you can make patches of alternatives and paste them over the colours you withdraw to your reserve collection. You might find, for instance, that after trying out a red from another manufacturer's range it suits you better.

▲ *You can easily make your own colour chart by ruling a series of large rectangles with a soft pencil. Use 300 gsm (140 lb) Not watercolour paper – the reverse of a used piece that you do not wish to keep will do. Paint in graduated washes of each of your colours using the same layout as in your paintbox. Under each colour add the manufacturer's name and the number of that colour for reference when refurbishing your stock of pans or tubes. It is also useful to prepare other rows in your chart to record new colours that you may add to your stock from time to time.*

CHOOSING COLOURS

We each have our own favourite pigments and their use often indicates the identity of the individual artist.

The following information should help you to gain a good working knowledge of colour mixing, but there is no substitute for personal experiment. If you go on to make many flower portraits you will need to add to your range of colours from time to time. You can always make life simpler by purposely buying a tube or pan of the nearest colour match for any particular specimen of flower.

YELLOWS AND REDS
These pigments are the warmest colours in your paintbox.

Lemon Yellow: A very clear colour. Try it before experimenting with other yellows you have.

Cadmium Yellow: A strong colour which is often a good colour match. Will mix with blues to make slightly opaque greens.

Cadmium Orange: Useful for mixing darker greens; remember it is a yellow.

Vermilion: This wonderful pigment is velvety soft and can be used to tone down other colours. Use it as a base to which other reds can be added, or to render other reds less harsh.

Permanent Rose: A bluish red that is often nearer the true hue of a red flower than most other reds. The correct match can usually be obtained by the addition of only a touch of another red.

Carmine: True carmines were made from vegetable and insect dyes but today there are artificial pigments that produce beautiful and subtle pinkish red washes.

Cadmium Red: A good substitute for Vermilion. It is more transparent, a strong pigment with greater staining power.

Crimson Alizarin: A versatile dark red. Try using it before any other red just to find out if it will do the job for you.

Brown Madder Alizarin: Useful when you cannot decide if you want a red or a brown. It is good for 'ageing' green, for rust spots on leaves and for plant pots.

EARTH COLOURS
These pigments are ground from soils and rocks.

Raw Sienna: This pigment does not mix well with water, but it can be just the colour match you seek. Test its handling first. Use for describing sunlit patches on woody stems.

Yellow Ochre: Similar to Raw Sienna, this colour is favoured by many painters.

Burnt Sienna: Use for stems, branches, soil and small patches of local colour.

Raw Umber: Has a cool green-grey-brown tint.

Burnt Umber: A much warmer version of Raw Umber, quite useful for toning down, but remember that earth colours are not normally suitable for painting actual flower parts.

Tips

● Cadmium pigments will render mixtures slightly opaque.

● Using earth pigments for parts of your painting such as stems and some leaves will make the clean washes on the flowers appear brighter.

BLUES AND PURPLES
These paints offer a wide range of cooler colours.

GREENS
Use any of these manufactured greens judiciously.

BLACKS AND NEUTRALS
Any such pigment will help to quieten down a vibrant hue.

Coeruleum: A pale opaque blue that can be added to greens where you wish to create the effect of granulation.

Cobalt Blue: Arguably the most useful blue in your paintbox and can be used to replace any other blue if necessary.

French Ultramarine: Very useful, but reserve it for making only the darker greens.

Permanent Blue: This is a strong man-made pigment. When diluted it gives a clean wash, and mixed with yellows it gives clean and clear greens.

Permanent Magenta: A fugitive colour, but mix with a little red for deep pink flowers.

Permanent Mauve: A clear colour. Use it to place pale shadows on petals.

Cobalt Violet: A weak colour that gives subtle changes to many flower mixtures. It granulates and does not go far.

Sap Green: If in doubt start off your leaf with a pale wash and add yellows and/or blues to it in subsequent washes.

Hooker's Greens Nos 1 and 2: These are well-tried standards to start your painting with, but always add a little yellow. They have greater staining power than Sap Green.

Viridian: Strong, but may be mixed with any pigment, particularly with oranges, to make a wide variety of other greens.

Ivory Black: This is a soft black made from charred bones. It should only ever be used judiciously to darken or dull a tone. Mixed with Cadmium Yellow it will produce a range of luscious greens.

Lamp Black: Like most other blacks it is really a very deep blue.

Neutrals, Greys, Sepias etc.: If you happen to have any of these colours in your box try using them for outlining and making very pale shadows.

Tips

● Capitalize on the granulation that occurs with some pigments.

● As a rule add the stronger colour little by little to the weaker one.

● Begin any painting with as few colours as possible.

WATERCOLOUR TECHNIQUES

The term 'wash' is used to describe the method of applying paint in broad areas without an outline, as the skies in landscapes, but it also refers to tiny marks made with the smallest of brushes.

Purist watercolour artists strive to obtain their desired effects of colour and tone with only one wash. Flower painters are not so restricted. It is possible to make many adjustments by combining various techniques.

There are two fundamental types of wash used for most techniques – the flat wash and the graduated wash. Both may be used on their own, or superimposed over any wash that has first been allowed to dry, with diverse results.

◄ Flat washes vary from a single tiny brush stroke to the covering of a large area. The normal way you will begin painting a flower is to deal with it petal by petal, and leaf by leaf one at a time, covering the white paper with a flat wash to see the effect of adding a layer of colour.

▲ Here, several applications of flat washes are superimposed to partly cover one another, forming many further colours.

PREPARING A WASH

Your first wash will usually be very pale, so place several brushloads, or more, of clean water into one of the wells on the palette section of your paintbox or into a mixing dish. Add brushloads of paint to it until the mixture appears to be about right. Stir your wash and try out a stroke or two on a scrap of paper. Mix a greater quantity of the wash than you think you will need as it is difficult to repeat exactly the same proportions of pigment and water and to match the colour.

APPLYING A FLAT WASH

It often helps to first dampen the whole area with a wash of clean water applied carefully right up to the edges of the paper so that when the coloured wash is applied it can flow evenly up to the margins.

To apply a broad wash load your brush with the prepared mixture. Place the first stroke quickly, but carefully, and horizontally at the top of the area to be covered. Stir your mixture and then apply a second stroke just overlapping the bottom edge of the previous stroke. Repeat this until you have covered as great an area as you want.

▲ *Graduated washes describe variation in tone, from deep colour to almost clear water. Although they take a little more care than flat washes they are quicker to apply than building up flat washes.*

APPLYING A GRADUATED WASH

Tilt your work at 20–30 degrees. Apply the first brush stroke with the full-strength mixture. For the next, and all subsequent strokes, first add a loaded brushful of water to the mixture and stir well. Continue in this manner, finishing with a brush of clear water. You can do the opposite, that is add more pigment with each stroke, but this tends to be a less controllable procedure. It is particularly helpful to first dampen your paper here to assist the blending process.

FURTHER TECHNIQUES

The following pages show some of the traditional methods to use as and when they seem appropriate, and you may even be able to invent a few of your own. Remember there are no rules, only guidelines.

Try the techniques out on watercolour paper. This is a good reason for never throwing away or tearing up early paintings – they can be usefully recycled. Remember too that you may wish to refer back to an early flop for information on details or colour, and even to convince yourself from time to time that you have improved your skill. Use these pieces also for making rough sketches and as a trial area for your colours.

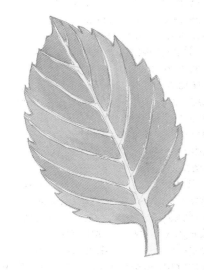

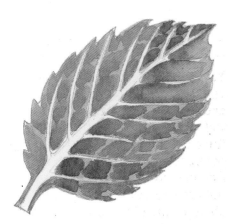

▲ *Here, each of the initial graduated washes is left to dry before a second graduated wash is placed over it from the opposite direction.*

▲ *Applying flat washes to a leaf. When the first yellow wash is dry fill in the spaces between the veins with a flat green wash. Apply a third flat wash to the even smaller areas outlined by minor veins.*

▲ *Filling a complex shape with a wash. During the time taken to follow carefully round the indentations the wash may form hard edges. Aim at alternating brush strokes that trace the edge with ones that do some filling in.*

▲ *Bleeding can happen when you apply a wash to an area abutting a previous wash that has not completely dried. This can present you with unorchestrated pleasing effects. Capitalize if at all possible.*

▲ *Colour variations. Here, two graduated washes are used in each example. Apply the second wash when the first one is dry, and from the opposite direction.*

▲ *To alter the tone of a wash (a), immediately blot it with paper tissue if too strong (b), or add more washes if too weak (c).*

▲ *Wet into wet is working one colour into another before either of the colours has dried. It creates the effect of mixing colour on the paper rather than the palette and gives unpredictable, but interesting, results.*

24

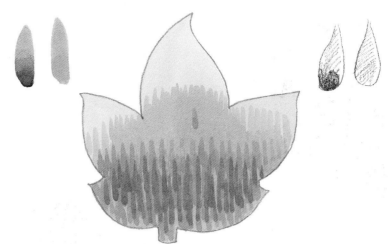

▲ Masking fluid is a rubbery solution used for keeping areas of the paper white. Here, masking fluid was applied to the mid-rib of the leaf and left to dry for a few minutes before painting over it. When the work is completely dry the masking solution is rubbed away with the fingers and finally cleaned up with a plastic pencil eraser.

▲ Dry (damp) brush work is a more advanced technique that methodically builds up tone layer upon layer in a way similar to shading with a pencil. Dip a small brush, size 3 or under, into the wash and remove excess moisture by dragging the brush over the edge of the palette, or by gently touching it against the paint rag, leaving the brush just damp. The

correct brush stroke is one that gives an even coverage. If there is a pool left at the end of the stroke remove some more of the moisture from the brush and try again. An occasional space left between strokes will prevent the end result from appearing too heavy.

▶ Lifting out is a way of lightening, or even removing parts of a wash and it is a favourite method of portraying veins on leaves without leaving any harsh edges. Rinse a small brush in clear water and use it to trace a fine and short length along the main vein to loosen the pigment, then immediately blot it. Repeat the procedure until you achieve the effect you desire. You can start lifting out as soon as the wash begins to dry, but for a sharp line the wash must first be quite dry. For stubborn pigments use hot water and a brush that has lost its soft point, flattening the hairs to make a wedge shape.

▲ Stippling is using the tip of the brush to paint small dots of varying tone and density to model small areas precisely or to soften hard edges. You can also splay out the hairs of an old brush to make the process quicker.

Tips

● Be ready to blot anything that seems unsatisfactory.

● An old piece of towelling laid across your lap makes a ready paint rag and keeps you clean.

FLOWER STUDIES

Flowers offer an unending source of interesting and easily available subjects in a multitude of colours, shapes and sizes, from familiar favourites to prize rare specimens. The basis of any convincing flower portrait is observation and learning to convey a true representation of what you see.

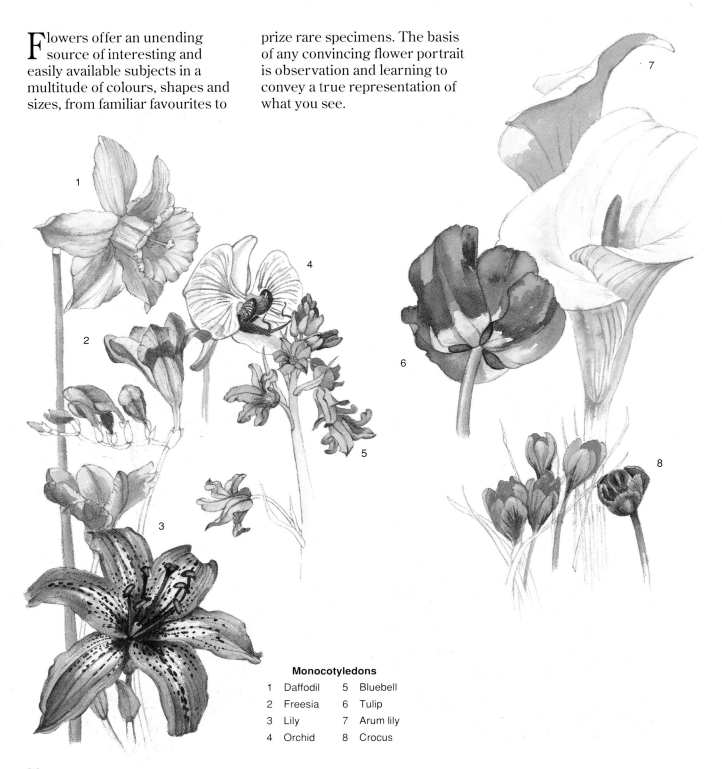

Monocotyledons

1	Daffodil	5	Bluebell
2	Freesia	6	Tulip
3	Lily	7	Arum lily
4	Orchid	8	Crocus

Practice is the only sure route to accurate drawing and it is important to make the most of any opportunity you have to sketch flowers and plants. Do not forget the obvious everyday flowers, but also buy or ask to borrow unusual plants and flowers whenever possible.

Start by concentrating on single blooms, and remember to include studies of side and rear views of flowers as well as drawing them face on. An understanding of the growing habits of individual species will give variety and dimension to your subsequent compositions.

Tip

● Do not forget to keep your plant watered – you can always spare some water from your paint jar.

Dicotyledons

1 Fuchsia
2 Aquilegia
3 Clematis
4 Dahlia
5 Marguerite daisy
6 Loosestrife
7 Pelargonium
8 Convolvulus

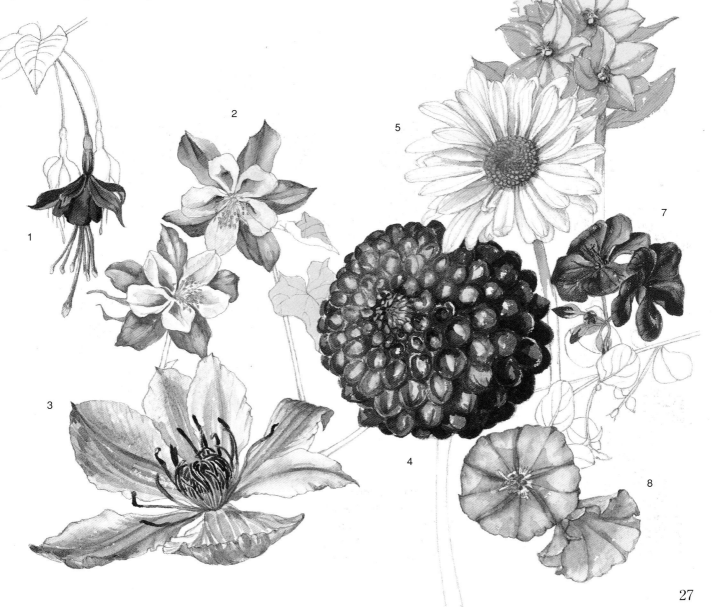

LEAF STUDIES

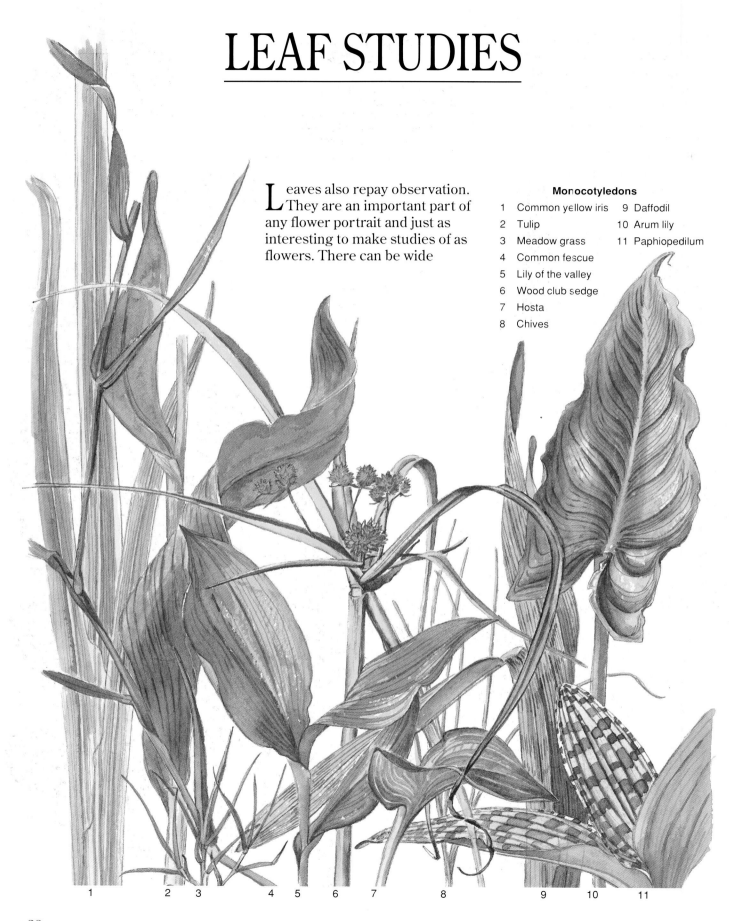

L eaves also repay observation. They are an important part of any flower portrait and just as interesting to make studies of as flowers. There can be wide

Monocotyledons

1 Common yellow iris
2 Tulip
3 Meadow grass
4 Common fescue
5 Lily of the valley
6 Wood club sedge
7 Hosta
8 Chives
9 Daffodil
10 Arum lily
11 Paphiopedilum

variation in the coloration of most species of leaf, much of which may depend on the stage the plant has reached in its life cycle.

Most leaves can be tackled in the same way. First paint the whole leaf shape with a pale green or yellow wash. When that wash is dry use a deeper green to paint in the prominent veins. You may find it helpful to first draw in the veins lightly with a pencil, either before or after the first wash. Fill in the areas between the veins and apply more washes to the spaces that often stand proud of the minor veins, which you may not actually be able to see.

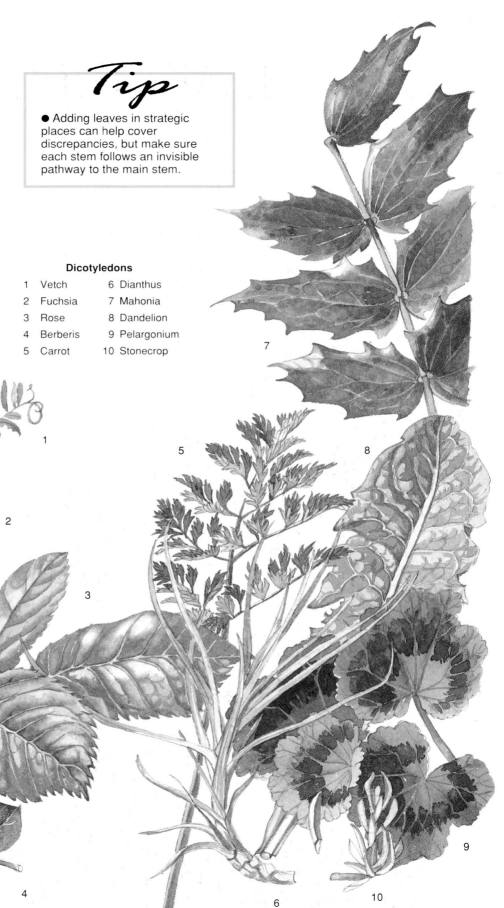

Tip

● Adding leaves in strategic places can help cover discrepancies, but make sure each stem follows an invisible pathway to the main stem.

Dicotyledons

1	Vetch	6	Dianthus
2	Fuchsia	7	Mahonia
3	Rose	8	Dandelion
4	Berberis	9	Pelargonium
5	Carrot	10	Stonecrop

PENCIL DRAWING

Carbon and coloured pencils are primarily linear tools, but you can use them to produce an extensive variety of marks – thin, thick, long, short, straight, curved, broken or continuous – all in endless combinations. Drawing from nature requires only freehand serpentine lines, but you can use a ruler to make feint guidelines if they will help.

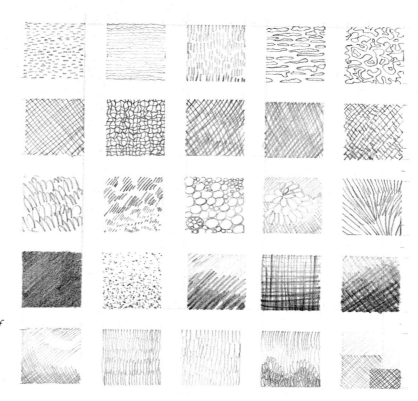

▶ *You can build up tone easily and rapidly with pencils, using a variety of single marks or combinations of marks in different directions and thicknesses of line.*

◀ *Coloured pencils allow you to add the dimension of colour to tone. You can mix the colours visually on the paper by overlaying strokes.*

FREEHAND DRAWING

There are two simple methods of freehand drawing.

The first is to concentrate on drawing the outline of the subject, totally ignoring its individual parts. Then fill in the rest of the drawing.

The second approach is to choose a feature of the subject that looks easy and begin by getting just that bit right before turning your attention to the other parts, again bit by bit.

With both methods it may help to indicate a few simple guidelines first, such as a cross at each extremity or a circle roughly the same size as you wish the flower drawing to be. However, it is looking, seeing and understanding your subject that pays the real dividends.

MEASURING TECHNIQUES

It is important to be able to make an accurate drawing, and there are measuring techniques which can help you to do this with the aid of a ruler or just by using your pencil as a measuring tool.

Proportional dividers may also be used to convert measurements to scales other than life size.

First choose a viewpoint that is attractive and that is readily re-established. Line up your subject against two objects in the room that intersect your subject, one for the vertical reference and another for the horizontal, and finally, make sure to sit down each time in the same place. It is important to keep your points of reference as only small alterations of viewpoint can mean that you find yourself trying to draw the side views as well.

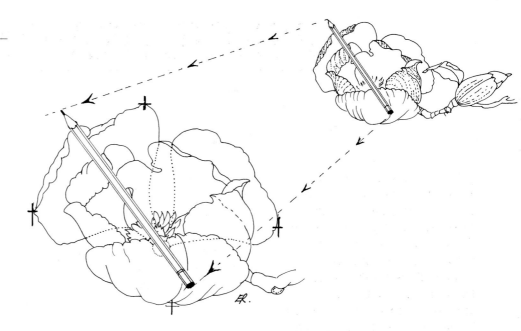

▲ *Measuring the correct angle of each petal. Hold a pencil at the angle the petal makes from its base to its outer edge and slowly bring it down to the surface of your paper, maintaining the same angle. Draw crosses on the paper to indicate where the petal should be placed. These marks need to be quite heavy as it may be necessary* to make several attempts at drawing the shapes of the petals. The crosses should remain throughout the drawing as a safeguard against the flower 'growing'.

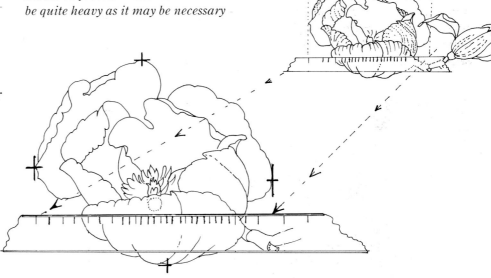

▲ *Measuring the correct dimensions of the whole flower. Hold a transparent ruler horizontally in front of the flower, just touching the nearest petal. Make two marks on the paper to indicate the flower's correct dimension at its widest part, then turn the ruler vertically and make two marks to* indicate its height. Draw a small circle about the size of the diameter of the stem in position where it is attached to the base of the flower. Before proceeding to draw the flower spare a few minutes to observe the subject better, even looking behind it to see how all its parts fit together.

ADDING TONE

Next to the importance accorded to accurate drawing is the matter of building form or creating modelling with tone.

With pencil you must make your picture within similar limitations to those of black and white photography, but since the pencil is a more versatile tool than the camera you can be selective. Be careful not to confuse hue or local colour with tone – it is easy, for instance, to mistake the deep red hue of a red rose for the dark shading required for showing the dark shadow cast by that rose. Go carefully; as a general rule it is better to underplay shading flowers and to reserve it for the leaves where it may serve to act as a foil for a delicate bloom.

Tone is best built up with fine lines. Dense overall shading, which is easily and quickly obtained by rubbing the pencil lead over the paper, always appears dull in comparison, but sometimes it is all you will have time for in a sketch snatched from life.

Tones can be worked up gradually using carbon or coloured pencils, which are very controllable. Reserve the deepest tones for where you are quite sure they are best placed. Remember that a flower portrait is an artistic representation, not an attempt to recreate nature.

Sometimes it can pay to ignore what you have observed as the strongest tone and place it instead in a more strategic position to help your design. In pencil drawing it is often possible to use very deep tones; certainly they can be much stronger than those normally used in a watercolour painting.

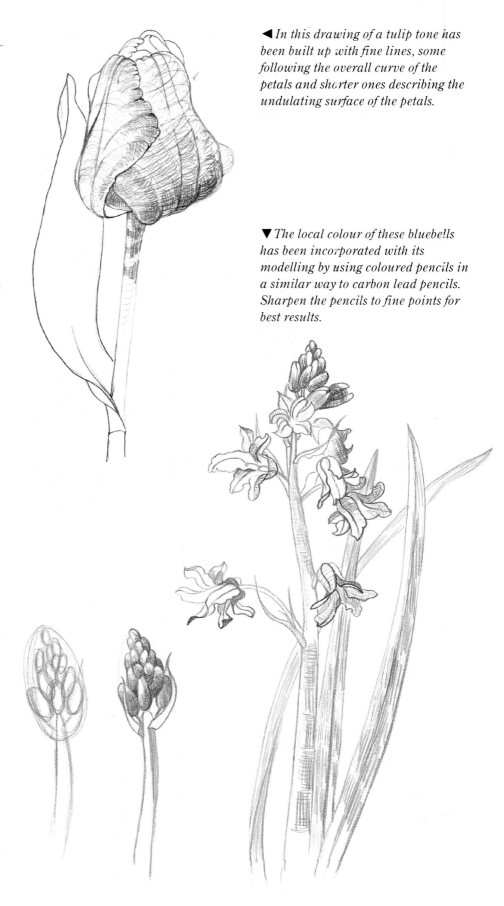

◄ *In this drawing of a tulip tone has been built up with fine lines, some following the overall curve of the petals and shorter ones describing the undulating surface of the petals.*

▼ *The local colour of these bluebells has been incorporated with its modelling by using coloured pencils in a similar way to carbon lead pencils. Sharpen the pencils to fine points for best results.*

LOOKING AT SHAPES

When starting to draw it is helpful to think of nature in terms of geometric shapes – for instance, stems as cylinders and flowers as spheres or as combinations of cylinders and spheres. Opening flower buds often resemble cones or upturned cones. A bunch of flowers assembled for a still-life painting may also resemble one or more of these simple shapes, and if you are aware of the basic rules of light and shade on those shapes you can adjust your tones accordingly to convey depth in your work.

DRAWING ELLIPSES

A little knowledge of how circles appear in perspective will help you to draw objects like flower pots, vases or saucers.

A false assumption frequently made is to assume that circles in perspective do not appear as true ellipses. The argument put forward is that since the nearer half of the ellipse is close to the viewer it should appear larger than the other half.

What actually happens is that it is the circle that is to be drawn in perspective, so that the rim of a plant pot viewed at an angle forms a true ellipse but the distance between the plant growing from the centre and the nearer edge will appear greater than that between it and the far edge of the pot.

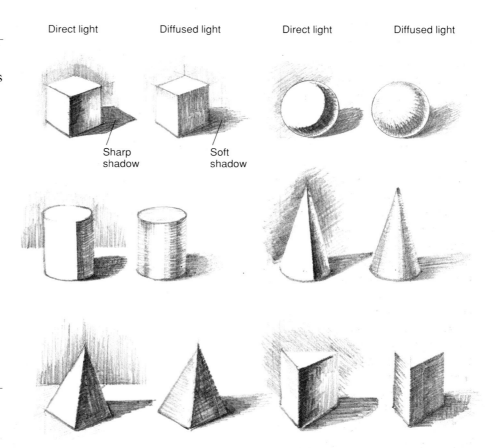

Direct light Diffused light Direct light Diffused light

Sharp shadow Soft shadow

▲ *Every form observed in nature can be simplified into one or more of six basic shapes – the cube, sphere, cylinder, cone, pyramid or triangular prism. When any one of these basic shapes is lit by a strong light source it is comparatively easy to see just where* the main shading should be placed to give that shape form. When the light source is weak or diffused it can be helpful to remind yourself of the tonal patterns previously observed in better light and to use this knowledge to add modelling to your drawing.

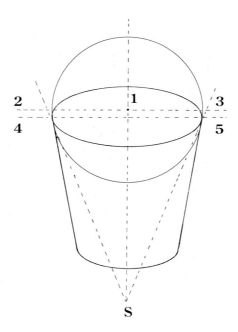

◀ *A viewer* S *looking at a sphere or cylinder dissected across its centre* 1 *from* 2 *to* 3 *is only able to see somewhat less than halfway round the object – the sight line stops at* 4 *to* 5. *How far round will vary with the increase or decrease in the distance between the viewer and the object. The larger the sphere or the closer the viewer, the less far round will be seen. A true ellipse is formed where the sphere is dissected at* 4 *to* 5 *and the viewer can see no farther round.*

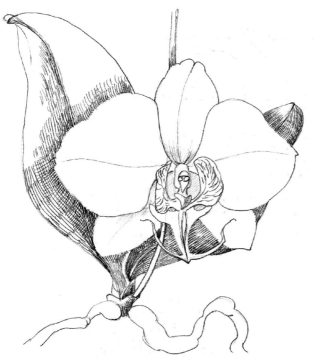

◄ *The delicacy of this orchid, or any white flower, presents problems when drawing or painting on white paper. One answer is to place it in front of a darker object, perhaps another flower in shade, but more usually some leaves. Only a very faint pencil line is used to outline the flower and the leaf is shaded right up to that line. If you cannot maintain the edge as accurately as you would like it can be tidied up with a small piece of kneaded putty rubber.*

DRAWING PRACTICE

Choose some simple objects, then take one and try drawing it, referring to the diagram of basic shapes if it helps. Remember anything goes that will help you reach your goal.

Repeat the exercise with other shapes, making sure to place them under the same conditions – lighting, surface and background – so that you may make proper comparisons. Observe the shading on an upright stem in full lighting, then look at flowers and leaves in the same way. If you do not know where to start simply imagine that you are following the shape of your flower with your pencil. Do this in different directions, feeling round the back of the whole flower, each petal and even each section of the petal. The modelling will gradually appear as you work. Do not rub out the first tentative strokes; they will cease to dominate as the drawing continues to progress.

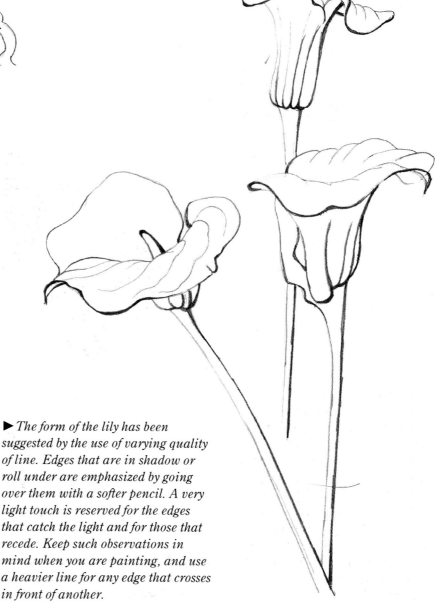

► *The form of the lily has been suggested by the use of varying quality of line. Edges that are in shadow or roll under are emphasized by going over them with a softer pencil. A very light touch is reserved for the edges that catch the light and for those that recede. Keep such observations in mind when you are painting, and use a heavier line for any edge that crosses in front of another.*

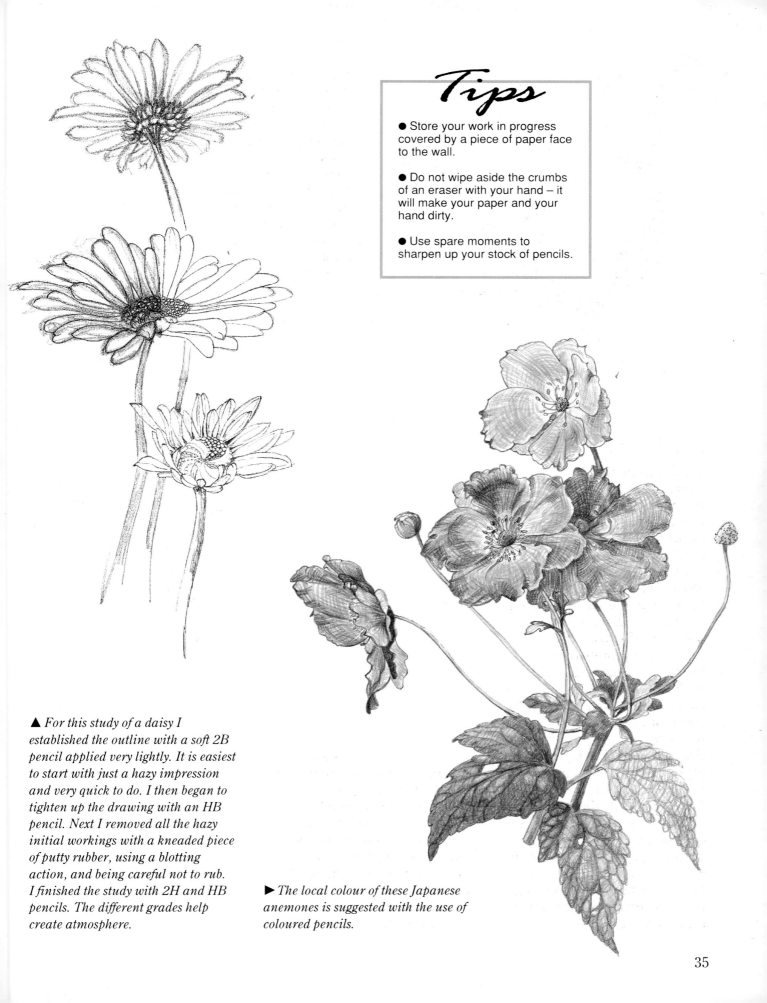

● Store your work in progress covered by a piece of paper face to the wall.

● Do not wipe aside the crumbs of an eraser with your hand – it will make your paper and your hand dirty.

● Use spare moments to sharpen up your stock of pencils.

▲ *For this study of a daisy I established the outline with a soft 2B pencil applied very lightly. It is easiest to start with just a hazy impression and very quick to do. I then began to tighten up the drawing with an HB pencil. Next I removed all the hazy initial workings with a kneaded piece of putty rubber, using a blotting action, and being careful not to rub. I finished the study with 2H and HB pencils. The different grades help create atmosphere.*

▶ *The local colour of these Japanese anemones is suggested with the use of coloured pencils.*

MAKING A MASTER DRAWING

Unless you are very experienced, or a gifted draughtsman, you may not feel competent to attack an expensive sheet of watercolour paper without any preliminary work. A reliable procedure is to use a master drawing from which the main outlines are pressed through with the aid of tracing-down paper, which acts in a way similar to office carbon paper.

Your drawing can be worked up to your complete satisfaction with as much alteration as required, on any size of paper, and the whole or only part of it pressed through and used for your final picture. This method can save time as there is no need to start a picture all over again, and allows you another try at the same subject but perhaps with a different medium.

A master drawing will be your working reference so use it to collate as much information as possible on one sheet.

HOW TO USE A MASTER DRAWING

Take a single sheet from your pad of layout paper – if you leave it in the pad you may accidentally make unwanted impressions on the sheets underneath. As this paper is partly transparent it is advisable to place it over a clean sheet of smooth white paper, such as the reverse of an earlier piece of work on HP paper.

▲ *Initial pencil study of a Common Yellow Iris.*

Do not worry about making mistakes. If it is a bad mistake just abandon that drawing and start again. Do not use an eraser; it is time consuming and may leave a mess. Find your way using a light touch with the pencil – perhaps a 2H – and only reinforce the lines when you are satisfied with your drawing. The lighter, exploratory ones will fade into insignificance.

Such a worksheet, although unplanned, often turns out to be an attractive piece in itself, well worth keeping. If large, it can be folded inwards on itself to store with other smaller sheets. If you are industrious this information bank can be utilized years later, to re-create similar pieces, to help build up a more complex work, together with other material, or as a source from which small portions can be extracted for projects such as greetings cards.

Remember to name the plant, describe where it came from, the date it was collected and the date of the drawings. It is most important to label your finished work correctly, and if you are unsure of your ground only label in general terms. You may also wish to include many more written notes, particularly if you intend to complete the finished work at a later date.

Sometimes a flower will be on the point of dropping its petals, or altering its appearance. This is the kind of occasion when it will prove beneficial to record the modelling, by shading with a soft 2B or 4B pencil. You must weigh up the benefits of doing this against the possibility of rendering the outlines less easy to read. Of course it is not essential to record the colour match as this can be determined later from similar blooms not fully opened.

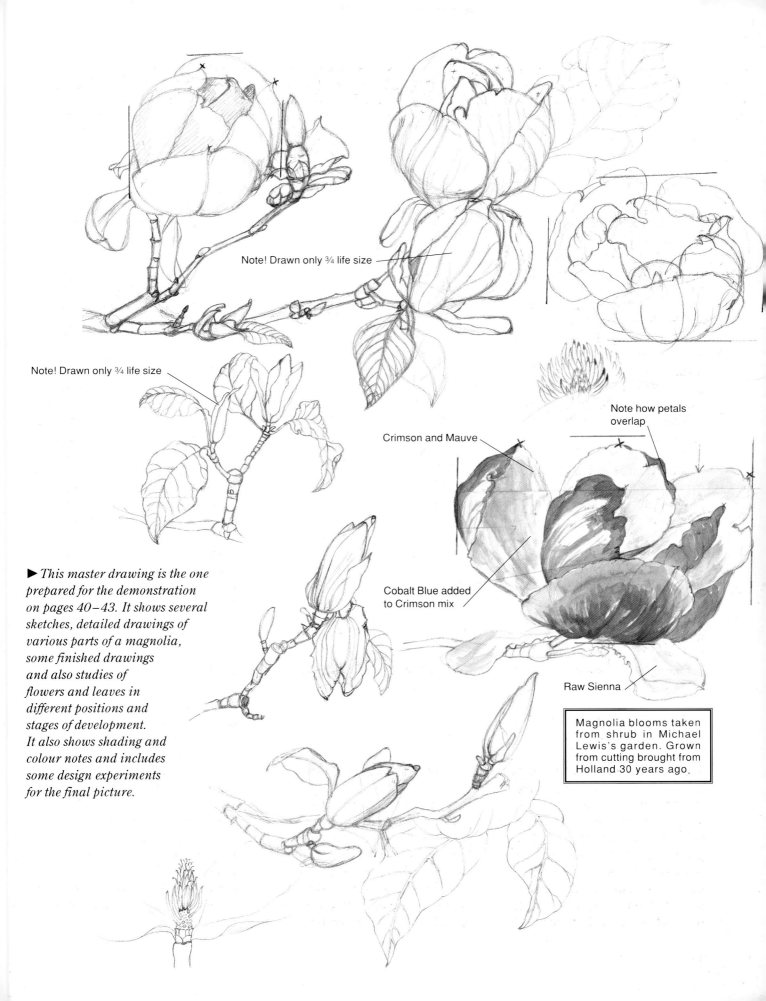

Note! Drawn only ¾ life size

Note! Drawn only ¾ life size

Note how petals overlap

Crimson and Mauve

Cobalt Blue added to Crimson mix

Raw Sienna

► This master drawing is the one prepared for the demonstration on pages 40–43. It shows several sketches, detailed drawings of various parts of a magnolia, some finished drawings and also studies of flowers and leaves in different positions and stages of development. It also shows shading and colour notes and includes some design experiments for the final picture.

Magnolia blooms taken from shrub in Michael Lewis's garden. Grown from cutting brought from Holland 30 years ago.

COMPOSITION

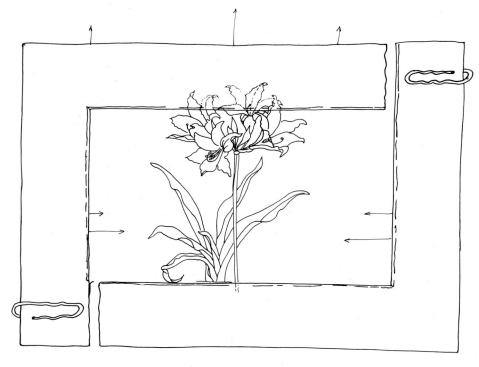

▲ *By moving the left-hand section of the frame towards the right and upwards, and the right-hand section inwards a pleasing picture format is decided upon.*

Before you start pressing through your master drawing you should consider the composition of your proposed painting. You may already have a clear idea of how you wish your picture to look and have decided its size, shape and colour scheme. However, a truly satisfying picture can be achieved by building it up stage by stage only when you are certain that you want to make a flower portrait of a particular specimen you admire.

PROPORTION AND LAYOUT

If you are uncertain how to compose your picture it is a good idea to place your first drawing towards the middle of a large sheet of paper, or on the Golden Mean. This aesthetically pleasing proportion, first described by the Ancient Greeks, divides space in such a way that the smaller part is to the larger as the larger is to the whole. In practice this works out to be roughly one third in from the edge of any one of the four borders.

A large cardboard mount cut through at two opposite corners will make an adjustable 'frame' that is a useful aid for designing the layout of your work. Your picture framer may have some discarded mounts or may be willing to make up a few.

It helps with framing to standardize the size of your paintings – about 35 × 25 cm (14 × 10 in) is a good average. The vertical dimension is always quoted first.

Place the mount over your work, then arrange it and the studies you would like to add to your first drawing within the space. Lightly draw in the border inside the mount and continue to compose within those four lines. The final size of your picture can still be adjusted. You may decide to show more of the plant and need to lower the bottom edge, or move the sides to accommodate more flowers, for instance.

Tip

● Protect your artwork while drawing by placing a clean piece of paper over all but the area you are currently working on.

PRESSING THROUGH

Having planned your composition, the next stage is to press through the outlines of your selected studies from your master drawing.

Place your master drawing over your watercolour paper and fix it at the top with masking tape or drawing pins. It should then not be moved until you have pressed through all the information you require.

Then place your piece of tracing-down paper under the master drawing with the pencil lead side downwards over the watercolour paper. With a 7H pencil or a dried-up ballpoint pen with a fine point, carefully go over the outline for about 2.5 cm (1 in). Lift up the corners and check the strength of the line and adjust your pressure accordingly. When you have gone over the whole outline of the flower check again.

Very often the outline is all you will need, but if the flower is large enough, press through some of its main features, such as some of its reproductive parts, just those sufficient to serve as guidelines.

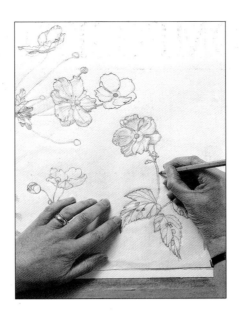

▲ *Using a 7H pencil or a dried-up fine ballpoint pen, press through those parts of your master drawing that you wish to use.*

▲ *From time to time, lift the master drawing and the tracing-down paper to see whether you need to adjust the pressure you are applying. Continue pressing through until you have sufficient lines to enable you to complete your picture.*

CHECKLIST FOR PAINTING A FLOWER PORTRAIT

As you work through the painting demonstrations and plan your own paintings you may find it helpful to follow this checklist of procedures.

1 Prepare a master drawing – a sheet of detailed pencil studies including colour notes in watercolour.

2 Select the flower study to be the focus of attention and press through its outline onto a sheet of watercolour paper.

3 Try out some colour experiments on a scrap of paper of the same type as you will be painting on to see if the colour notes are correct and how the paper will receive the washes.

4 With several washes you may be able to complete a single flower. Do this if it is to be the most prominent feature of the picture so that you are sure that it is finished before the flower has time to fade or change shape.

5 Resolve the remainder of the picture from the store of other material contained on your master drawing.

MAGNOLIA
DEMONSTRATION

I will go into more detail with this painting than in the demonstrations later in the book, and you may wish to refer back to it from time to time. As with later demonstrations, although the finished painting shows a complete composition, the stages concentrate on showing how one flower is achieved.

Using only a simple palette or colour range keeps the picture consistent, but with experience you will be able to incorporate many other colours to give added interest and a greater sense of naturalism. Your own choice of colours will give a personal feel to your interpretation of the demonstrations.

The Magnolia, family Magnoliaceae, has fairly large flowers that are a suitable size for a beginner to tackle. Magnolias are primitive flowers and their structure is easy to understand. The perianth is not clearly separated into corolla and calyx, so its petals and sepals are both referred to technically as tepals, but here I shall use the more familiar term of petal.

So that the flowers might be held firmly at something like the same angles as they grew on the bush I placed them in flower arranger's compound.

COLOURS
Raw Sienna; Crimson Alizarin; Permanent Mauve; Cobalt Blue; Lemon Yellow; Sap Green; Burnt Umber.

▲ *First stage*

FIRST STAGE
Using tracing-down paper I pressed through the outline of the first flower from my master drawing with a 7H pencil onto a sheet of 300 gsm (140 lb) HP watercolour paper. I positioned this flower in accordance with the Golden Mean, making it the focus of interest; any other material would be subservient to and supportive of it. I wanted to build up a picture with other flowers, unopened buds and a few leaves from the store of material on my master drawing.

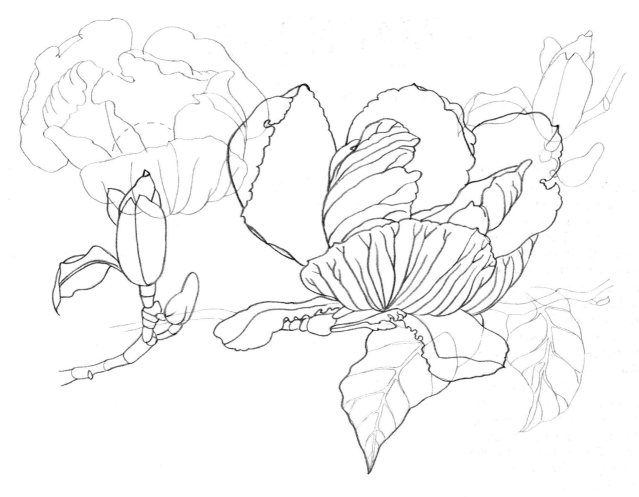

▲ *Second stage*

SECOND STAGE
After the outline had been pressed through I re-emphasized it using a 2H pencil, which makes a clear mark and one which will not easily be lost underneath paint, nor readily smudged and likely to dirty the paper. Now I was able to start work directly on the flower.

THIRD STAGE
I painted the inner surfaces of each petal individually with a pale wash of Raw Sienna. I loaded the brush, size 5, and began at the top, continuing downwards to the base with another brush loaded only with clean water.

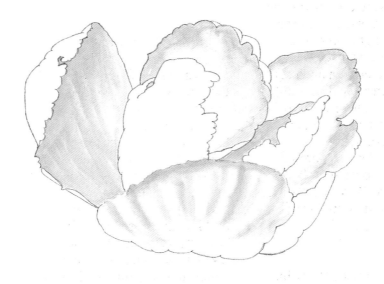

▲ *Third stage*

FOURTH STAGE

I mixed up a large quantity of a wash using Crimson Alizarin and Permanent Mauve to use as the main flower colour. I applied this wash to the outer surfaces of the petals with a size 5 brush, again using a second brush loaded with clean water for painting over the lighter areas, blending in the colours. I turned my work upside down to tackle the front petal so that the pigment would flow freely downwards. Using a size 3 brush I painted the shadows inside with a pale wash of Cobalt Blue to which a touch of the Crimson/Mauve paint mixture was added.

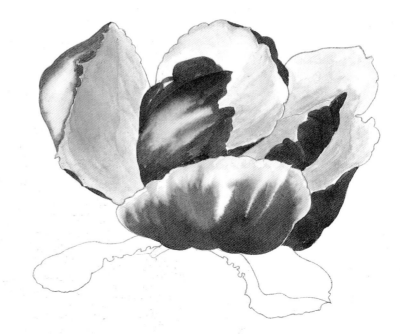

▲ *Fourth stage*

FIFTH STAGE

Using some of the Crimson/Mauve mix and a size 0 brush, I drew in the more prominent veins on the flower.

I started placing some of the leaves right at the front, knowing that they would not have any drawing put over them. With a size 3 brush and a wash of Lemon Yellow I painted the whole leaf areas, which fixed the pencil drawing of the minor veins. I then began defining the larger spaces between them with a wash of Sap Green mixed with a touch of Cobalt Blue. I outlined these spaces with the size 3 brush and blended the wash with a brush loaded with clean water so that the very centre of each space was still a clear yellow.

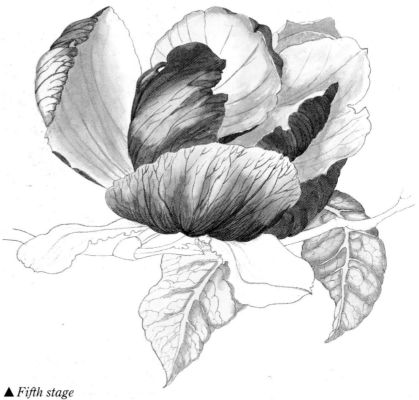

▲ *Fifth stage*

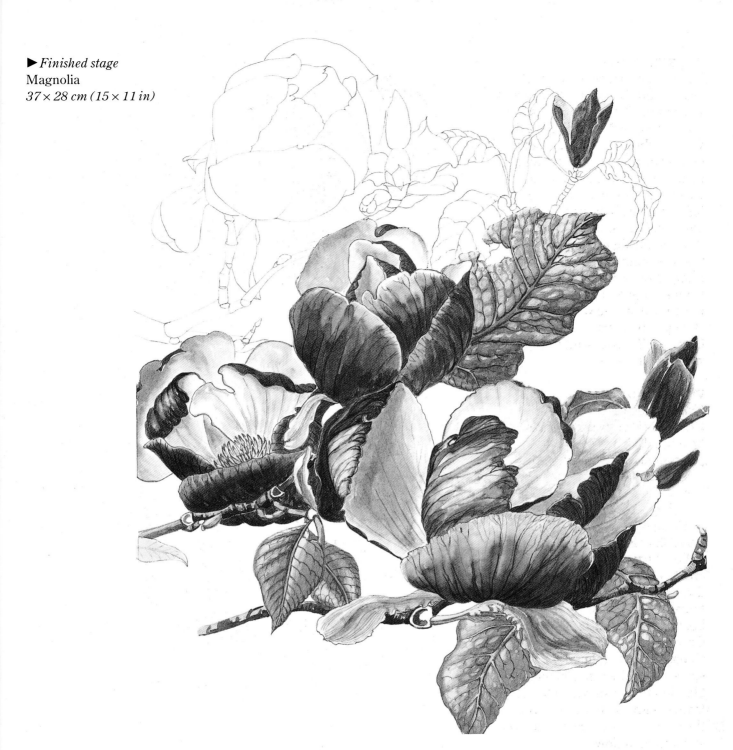

► Finished stage
Magnolia
37 × 28 cm (15 × 11 in)

FINISHED STAGE

I dragged a size 5 brush loaded with clean water swiftly across the parts of the petals where the veins of the flower were barely visible to soften some lines.

I added the outlines of other flowers, buds and leaves by pressing through some of the studies from my master drawing.

While doing this I placed scraps of paper directly on top of the finished portions of work to avoid marking the watercolour paper.

The leaves were first painted with Lemon Yellow, and built up with washes of Lemon Yellow to which various amounts of Cobalt Blue and Sap Green were added. I added a touch of the Crimson

and Mauve mix for the darkest green parts, and to outline the main veins. I began painting the twigs with a wash of Raw Sienna and Burnt Umber, and again added some Crimson/Mauve mix, this time dropping it from a small brush directly onto the wet wash as it dried, leaving the paint to flow naturally.

COMMON YELLOW IRIS
DEMONSTRATION

I unexpectedly came across a bed of yellow iris, *Iris pseudacorus*, growing alongside a stream bordering a boatyard. The proprietor of the yard gave me permission to gather a few flowers and as they would not flower again for twelve months this was an opportunity that had to be seized. I picked several spikes, one of which had a flower that was still in bud.

An iris flower can seem to be complicated to draw, but referring to a botanical textbook will help. Note that iris leaves are quite yellow when young – the deep green first appears along the centre main vein and then radiates towards the edges, often stopping just short of the margins.

COLOURS
Lemon Yellow; Cadmium Yellow; Permanent Blue; Crimson Alizarin; Burnt Umber; Permanent Mauve.

FIRST STAGE
I began by drawing two views of the flower on layout paper (see also page 36). In drawing the details I closely observed just how each part grew and which part of the flower was placed in front of which other. I also drew the outlines of a leaf and sketched a few more in different positions to be used for later compositions.

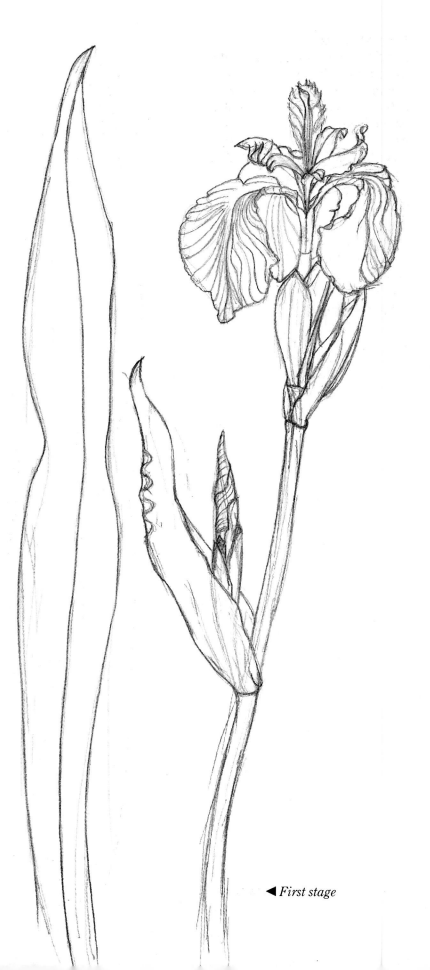

◀ *First stage*

SECOND STAGE

I decided to press through only the outlines of a single flower and leaf in the middle of a sheet of 300 gsm (140 lb) HP watercolour paper. This placing meant that I would be able to load the design on either side with other studies later if I wished.

With a size 3 brush I painted the flower and bud with a wash of Lemon Yellow, then used this yellow to paint the edges of the leaves and the flower stalk. I then added some Permanent Blue to the yellow and began painting the leaf areas.

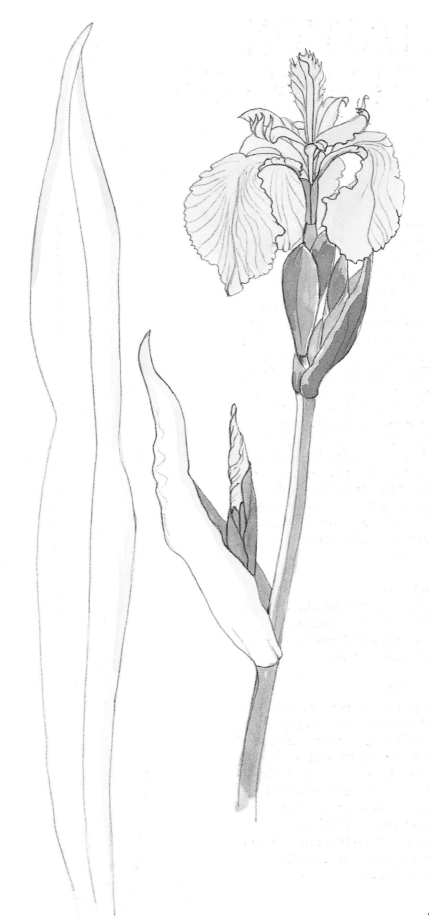

► *Second stage*

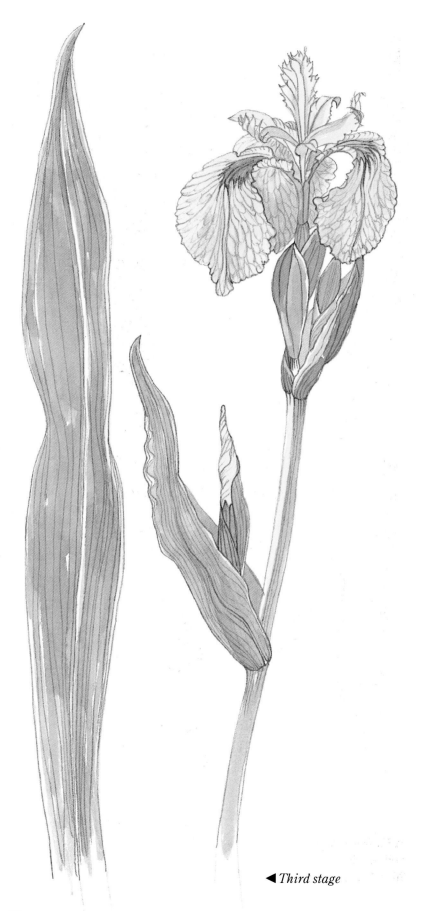

THIRD STAGE

The leaf areas were filled in and the two shadow areas of the bracts, specialized leaves that had encased the flowers, were painted with a wash of Permanent Blue and a little Crimson.

In reality shadows on yellow flowers appear quite green, but somehow green shadows on a painting of yellow flowers nearly always looks wrong. I think it is best to keep their shading to a minimum, so I compromised by deepening parts of the petals and sepals with Cadmium Yellow.

With an HB pencil I drew in some of the details, particularly the parallel veins of the leaves and the minor veins of the flower. As all previous drawing was now safely sealed under the yellow and green washes I was able to use an eraser and make corrections when necessary.

◀ *Third stage*

46

FINISHED STAGE

With a deeper wash of green, using more pigment and a touch of Burnt Umber, I began to paint the spaces between the pencil lines on the leaves, making the brush strokes in the same direction as the veins. and from the base upwards.

All the rest of the work was now done with a size 0 brush. When the green was dry I emphasized some of the pencil lines with the wash that was now thickening up, and deeper, being careful to leave some of the distinguishing yellow margins on the leaves.

To indicate some of the minor veins of the flower I added a touch of Permanent Mauve to the Cadmium Yellow, and for the segment markings I used some Crimson and a touch of Burnt Umber. Finally I exaggerated the greenness of some of the reproductive parts, so that they might stand out from all the yellow in the painting.

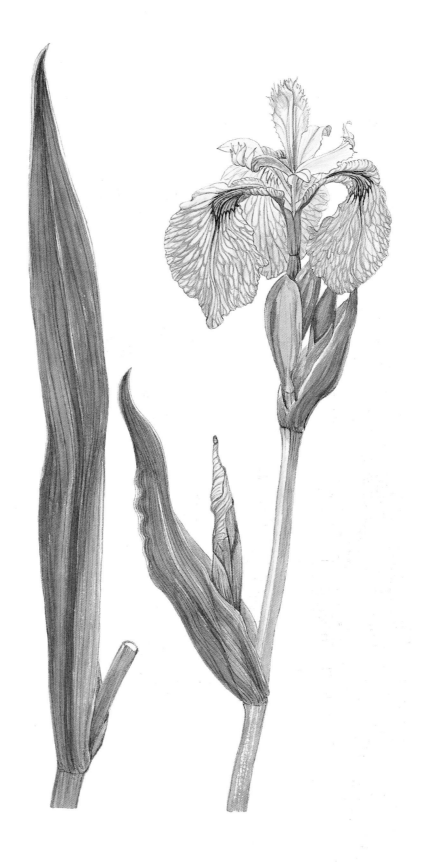

▲ *Finished stage*
Yellow Iris
36 × 19 cm (14 × 8 in)

POLYANTHUS
DEMONSTRATION

Polyanthus flowers are found in a multitude of colour variations from yellow, yellow with orange, through the reds and violets to deep blue. These showy potted plants are hybridized from the common yellow woodland primrose.

The leaves on different plants show considerable differences. Some are very crinkly and bend themselves into fascinating abstract shapes with bright highlights and deep shadows. Others have leaves that are nearly smooth, in soft mossy shades of green.

I did not consider it necessary to make a master drawing to tackle this subject as the plant would bloom for some time, but you may prefer to use that approach. You might choose to restrict it to a few of the more prominent flowers and leaves.

However, I did bring out the magnifying glass to examine the flowers closely. I opened out a flower with a sharp craft knife by splitting between two petals and following that down through its tube-like structure, opening the flower out into a fan shape. I placed it between layers of tissue and pressed down upon it with the heel of my hand, checked to see that it was still in position and that no petals had curled over, and gave it a further good pressing. If necessary you can carefully pin the flower open. A specimen treated in this way can be dried out and kept indefinitely.

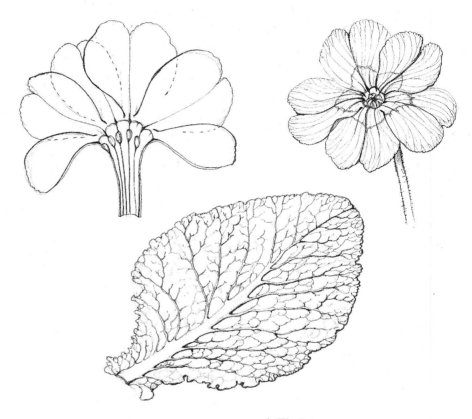

▲ *First stage*

COLOURS
Lemon Yellow; Cadmium Orange; Crimson Alizarin; Carmine; Hooker's Green No 2; Cobalt Blue; Vermilion.

FIRST STAGE
The first thing I discovered when I detached another single flower to begin a detailed drawing was that it had a different number of petals to the one I had dissected. About half the flowers had five petals and the others six petals. I made a few studies on layout paper, partly to find out more about these flowers, and also because such an exercise is rewarding for its own sake.

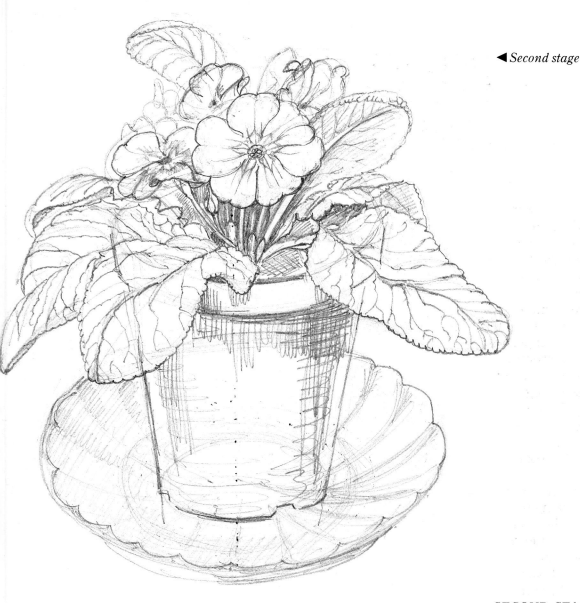

SECOND STAGE

I sketched out the whole plant in its pot onto a piece of 300 gsm (140 lb) HP watercolour paper, chosen for its smooth surface as I intended there to be quite a large element of pencil drawing made directly onto it. Doing this would also help me to form a good idea of how the final picture might look. I started the drawing with a soft 2B pencil, changing to an HB as it progressed. I made a few exploratory lines describing the ellipses made by the pot and saucer. I like to work out the exact lines of ellipses on a spare piece of paper or even do a master drawing.

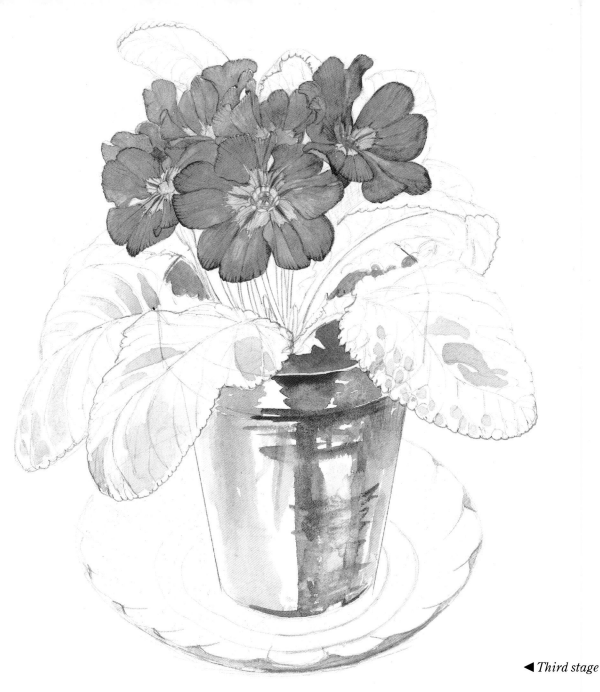

◄ Third stage

THIRD STAGE

Using a size 3 brush and a wash of Lemon Yellow I painted the centres of each flower and the triangular portions of the petals. Then, with a size 0 brush and a little Cadmium Orange, I placed the radiating marks onto the yellow while it was still damp.

I painted the remaining parts of the petals with a pale Crimson wash applied with a size 3 brush. When this was almost dry I began indicating the shadows and, changing to the size 0 brush and Carmine, drew in some of the veins. Some of the veins dried too hard, but they were easily softened with a little clear water.

I turned my attention to the leaves, roughly indicating those parts that were catching the light with a very pale wash of Cobalt Blue, using a size 3 brush.

I used a size 5 brush and a wash of Vermilion to which a dash of Cobalt Blue was added, but not stirred, to follow the curves of the pot, again softening here and there with clear water. Light Red is an exact colour match for a terracotta pot.

I used a weak wash of Cobalt Blue with a little of the nondescript debris lurking in the corners of my palette to tone it down to indicate the design on the saucer. It can be tempting to reproduce the vibrant colours on chinaware, but this can detract from the main subject, the flowers, if you are not careful.

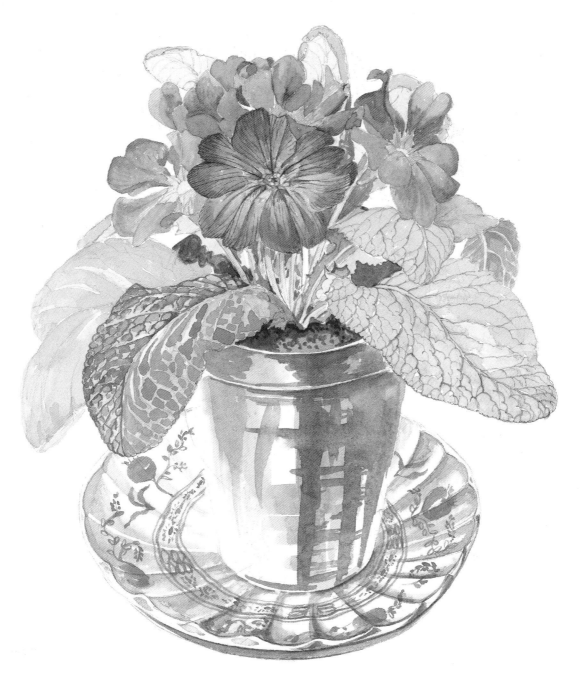

FINISHED STAGE

The next day I began by redrawing one of the higher leaves that had changed its position markedly. I covered the leaves with a pale wash of Lemon Yellow and Hooker's Green applied with a size 3 brush, avoiding the highlights.

I added some Cobalt Blue to the wash and began to fill in the spaces between the veins, using the same brush. Each of these small areas when seen in a strong light appear as a tiny mound, which can be indicated loosely, as here, or painstakingly moulded with minute dry-brush marks or by stippling. These more precise treatments make for tighter illustrations and, although I usually prefer to understate my watercolour paintings, there are occasions when I prefer to make a more meticulous rendition.

I turned the pot around and found that a different picture presented itself for me to paint.

▲ *Finished stage*
Polyanthus
35 × 29 cm (14 × 12 in)

USING PEN AND INK

Drawing with pen and ink adds a further dimension to a flower portrait, giving it a clean and authoritative look. An ink outline has greater strength than a pencil line, and if kept fine it can especially enhance a pale flower.

For maximum control it is again best to use a master drawing. Press through your flower study, then draw over the lines with pen and ink. Or you can make an accurate drawing with a soft grade of pencil, such as a well-sharpened 2B, straight onto your watercolour paper and then go over it with ink. Make a few test strokes with your pen at the outset at the far top corner out of the picture area as every paper, type of nib and ink give different results. If time allows leave your work overnight to let the ink dry out completely before erasing away all those pencil guidelines you are following.

If you feel sufficiently confident, of course, the quickest method is to draw straightaway with pen and ink, but this approach is normally reserved for sketching.

USING TRADITIONAL PENS

Dip pens of the traditional school pen design have changed very little over the years, but today the holders are more usually made of plastic. They take steel nibs which are available in many widths and profiles, from wide

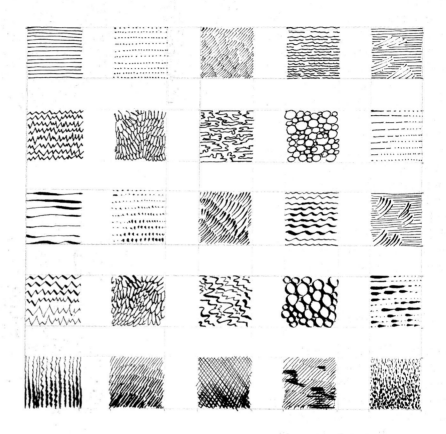

and flat-ended ones for a bold effect, oblique cut to give both thick and thin lines and for calligraphy, and fine mapping nibs. Find something that suits your style of drawing and stick with it.

A size 303 is a good all-round nib which gives a line that can be varied immediately by increasing and decreasing the pressure applied. Work done with this type of traditional pen is instantly recognizable as a piece of work executed by hand.

It is a good idea to have nib holders or pens in different colours for quick recognition.

▲ *There are innumerable combinations of different pen marks. The first two rows here were done with a technical pen and the rest were done with a dip pen. Find a few marks that you like and use them to help personalize your work.*

USING MODERN PENS

Technical drawing pens are the easiest to use. Their fine steel tube nibs give a constant and steady flow of ink, though their effect may make a drawing look a little contrived. Make sure you use the ink recommended by the manufacturer of the pen to avoid any clogging. Disposable pens are well worth the small extra cost if you want one only for occasional use. If you arm yourself with three thicknesses of nib, each giving a different thickness of line, you can achieve a very sympathetic drawing.

Ballpoint pens are useful for sketching and note making, but may blob if you use them too much in one direction. Hold a tissue or rag in your free hand and wipe the point frequently.

USING DRAWING INKS

A waterproof ink is the best overall ink to use for reliable results. Watersoluble inks give interesting effects when either a wash of clear water or a tinted one is added, but as any part of the drawing that is touched immediately begins to dissolve and mix with the wash results are unpredictable.

Traditionally, artists have used Indian ink, but many find its sheen on drying unattractive. You can mix other inks, either black or coloured, with it to alter the effect.

Sepia gives a soft, antique effect and is often used for flowers, but there are also extensive ranges of coloured inks that can be used on their own, together or mixed before use. They will give very clear colour washes if painted with a brush.

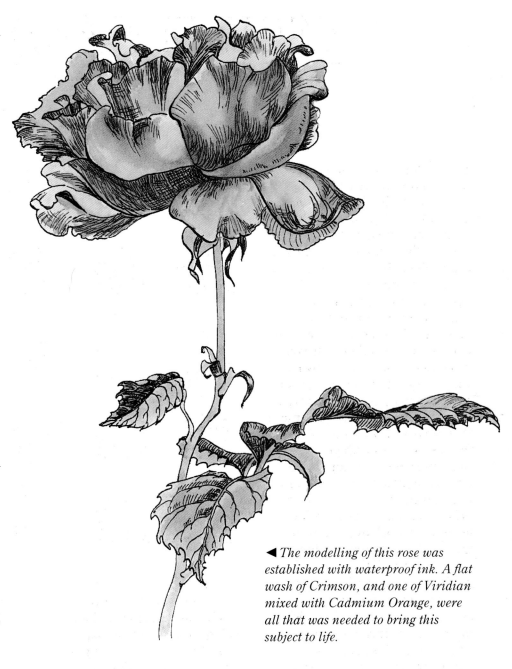

◄ *The modelling of this rose was established with waterproof ink. A flat wash of Crimson, and one of Viridian mixed with Cadmium Orange, were all that was needed to bring this subject to life.*

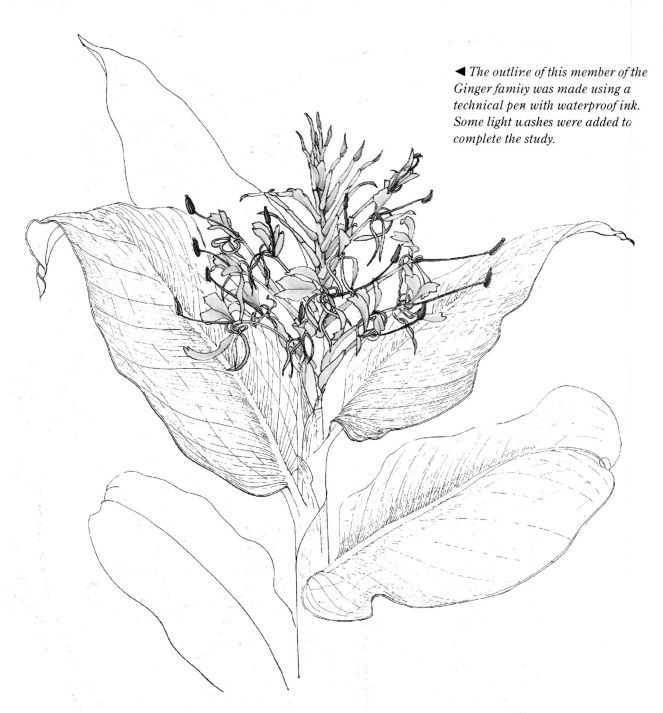

◄ The outline of this member of the Ginger family was made using a technical pen with waterproof ink. Some light washes were added to complete the study.

PEN AND INK PRACTICE

Marks made by pen and ink can be very varied, and as individual as handwriting. They can be used to convey the value of tone and surface texture, and it is great fun to spend some time experimenting to find new techniques rather than relying on the well-tried methods of cross-hatching and using parallel lines or dots to build up your drawings.

ADDING A WASH

If you have used a waterproof ink you can add colour washes without disturbing the drawing. If the use of ink has been limited to the outlines and certain main features you can proceed to apply as many washes as you choose until you achieve the desired effect. If you have inked in shading by cross-hatching or other pen strokes, you may find

that a single flat wash will be more than adequate. This is a very quick way of producing a crisp and colourful picture.

When the drawing has been done with watersoluble ink you should apply any wash with caution. Use a flat wash of any single pigment and gently engage it with the ink lines – the ink will mix with the wash to make a third colour. Make some tests on scrap paper first.

54

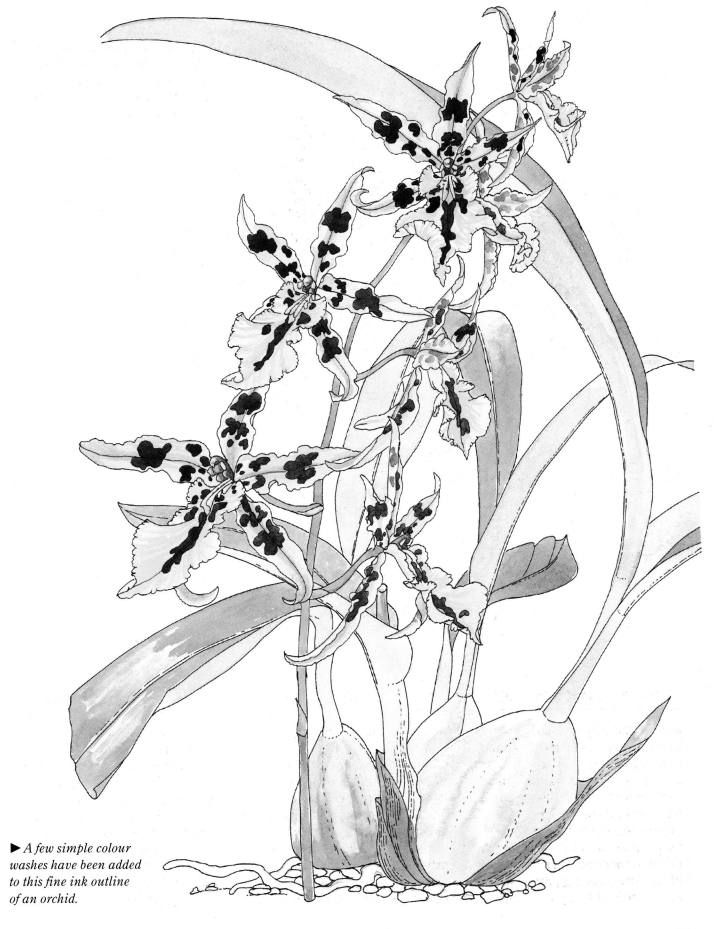

▶ *A few simple colour washes have been added to this fine ink outline of an orchid.*

POPPY
DEMONSTRATION

Poppies soon wilt, so when presented with a single large poppy cultivar I set to work as soon as possible, making studies of two views of the flower on layout paper. It was only when I came across the drawings during the following winter that I was inspired to create a flower portrait. I also had reference studies of other poppies, their leaves, seed heads and buds drawn at another time.

The finished flower portrait was drawn in ink, which gives clear, defined outlines to the coloured work.

Beginners sometimes find pen and ink easier as it allows you the freedom of erasing all your initial and unwanted pencil lines for a clean-looking piece of work.

COLOURS
Black waterproof ink; Cadmium Red; Cobalt Blue; Cadmium Yellow; Sap Green.

FIRST STAGE
As all the pencil marks would be erased as soon as the ink had dried, and as the structure of the poppy flower is relatively simple, it was not necessary for me to press through the flower heads. I decided not to draw all the details of the petal margins, but just try to convey the characteristic features of their form.

I roughly sketched the outlines of the petals and stamens with a soft 4B pencil onto a piece of 300 gsm (140 lb) Not

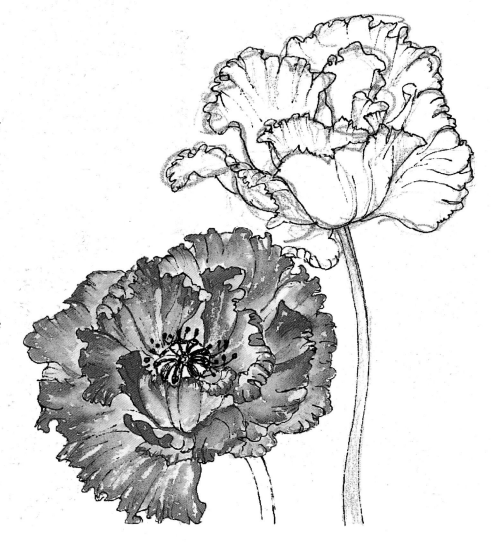

▲ *First stage*

watercolour paper with a hard surface. Then I drew over this sketch with a technical pen, now taking greater care in following the intricate frills and folds, and the details of the stamens. After erasing all the pencil marks I painted the petals with a size 5 brush loaded with Cadmium Red and lots of water.

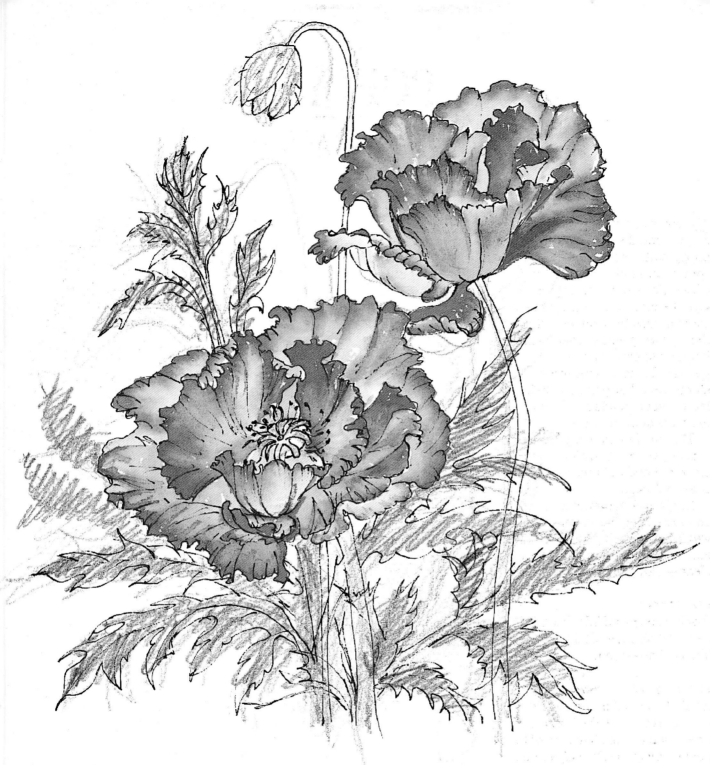

▲ Second stage

SECOND STAGE
After the flowers were finished I sought out some leaf studies with which to begin building up the composition. With the same soft pencil used on its side I loosely shaded in the shapes of the leaves, and drew them over with ink, again erasing the unwanted pencil marks.

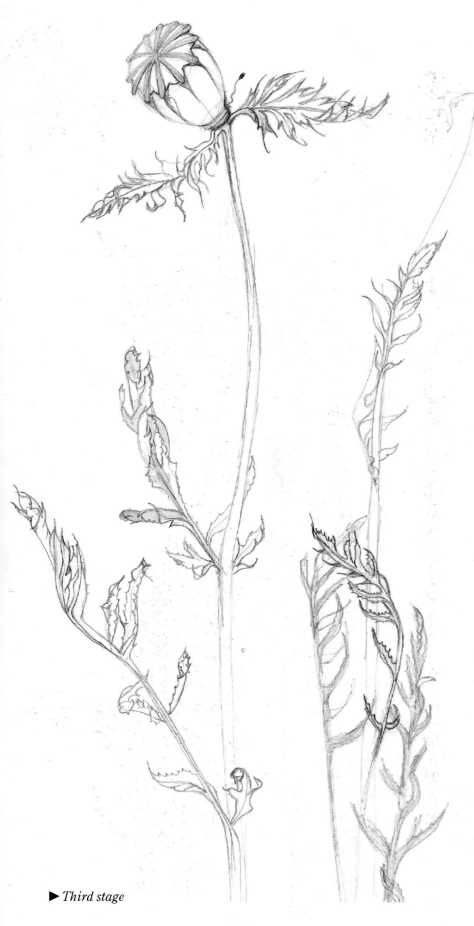

THIRD STAGE

Still not sure how to use the drawings of seed heads that I hoped to incorporate, I laid them in different positions over the flowers that had been painted. I could see through the layout paper well enough to determine where they should go. I pressed through these drawings knowing that any unwanted marks made on the finished areas could be erased later.

FINISHED STAGE

I now had a network of lines made where images that had been pressed through overlay one another and I had to decide which ones to make permanent by going over them with ink. I did this slowly until the effect was pleasing and left the ink to dry for half an hour. All the remaining pencil was erased.

The unstretched paper retained its hard surface as it had not been wetted and I now had great fun gradually painting in. I began with the fresh leaves, using a size 5 brush and Sap Green. The brittle leaves required some attention, although they would have been nearly colourless in reality, and I defined various parts with a weak mixture of the primary colours applied with a size 3 brush.

There were many possibilities open to me in creating this composition, but the important point to remember is not to ink in or paint anything until you are sure that it should remain a permanent feature of the work.

▶ *Third stage*

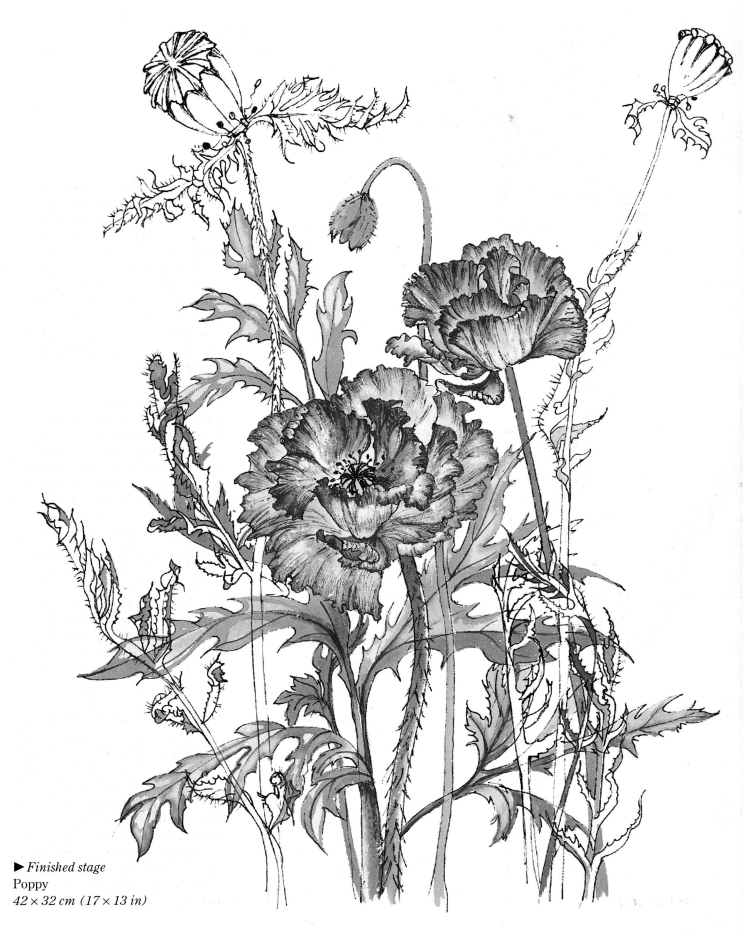

► *Finished stage*
Poppy
42 × 32 cm (17 × 13 in)

FOXGLOVES
DEMONSTRATION

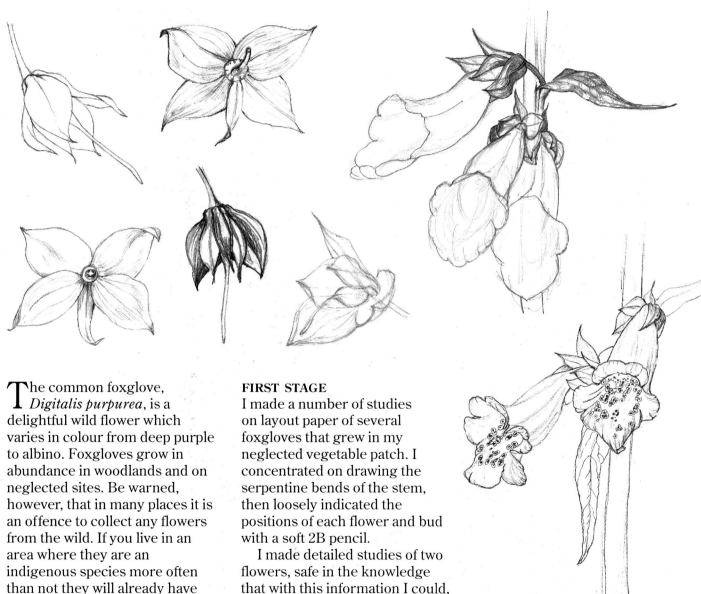

The common foxglove, *Digitalis purpurea*, is a delightful wild flower which varies in colour from deep purple to albino. Foxgloves grow in abundance in woodlands and on neglected sites. Be warned, however, that in many places it is an offence to collect any flowers from the wild. If you live in an area where they are an indigenous species more often than not they will already have seeded themselves prolifically n your garden.

COLOURS
Cobalt Violet; Lemon Yellow; Hooker's Green No 2; Carmine; French Ultramarine.

FIRST STAGE
I made a number of studies on layout paper of several foxgloves that grew in my neglected vegetable patch. I concentrated on drawing the serpentine bends of the stem, then loosely indicated the positions of each flower and bud with a soft 2B pencil.

I made detailed studies of two flowers, safe in the knowledge that with this information I could, if necessary, complete the others using this study as main reference. I did similar close observation studies of a leaf and the calyx, the green sepals that had covered the petals and now encircled the base of the flowers.

▲ *First stage*

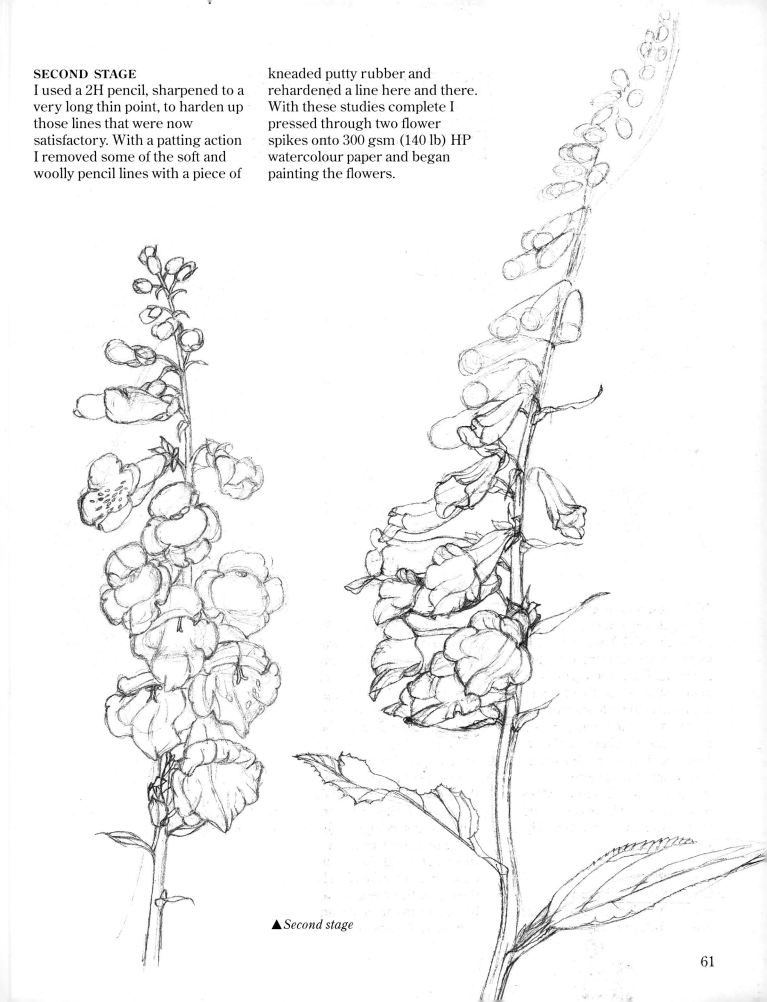

SECOND STAGE

I used a 2H pencil, sharpened to a very long thin point, to harden up those lines that were now satisfactory. With a patting action I removed some of the soft and woolly pencil lines with a piece of kneaded putty rubber and rehardened a line here and there. With these studies complete I pressed through two flower spikes onto 300 gsm (140 lb) HP watercolour paper and began painting the flowers.

▲*Second stage*

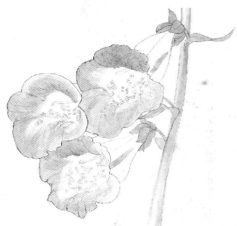

▲ *Third stage*

THIRD STAGE

Using sizes 3 and 0 brushes as seemed fitting, I laid down a pale wash of Cobalt Violet, blending it into pure water when approaching the area where the distinctive foxglove spots began. I also laid down a pale wash of Hooker's Green over the stem and calyx.

FOURTH STAGE

With a deeper wash of Cobalt Violet, Carmine and a little French Ultramarine, I carefully traced around the white collars that surround each of the deep purple spots. I added a little shading over the green parts with the wash that had now begun to thicken up on my palette.

FIFTH STAGE

With a yet deeper Violet/Carmine mix I moulded the outwardly curling petals and with a still more concentrated mix placed the spot-like markings.

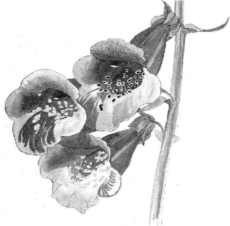

▲ *Fifth stage*

SIXTH STAGE

I defined the veins on the flowers and found that some were too heavy, so they were softened with a brush of clear water and by blotting. I added a little pure Crimson to the emerging reproductive parts and tidied up the outline. I pressed through the outlines of a few leaves.

FINISHED STAGE

When I had completed two foxglove stems I wished to enhance the design. I made a tracing of the outline on layout paper, cut around it with scissors and laid this simplified paper shape over the finished parts of my work to keep them clean. I could see the painting through this mask and placed the drawing of some flowers that had gone to seed on top and pressed through those portions that fitted onto the still empty central portion of my picture. I did the same with drawings of leaves and stems.

With a network of pressed-through outlines I enjoyed deciding which parts to paint and which lines to erase, or harden up. Some of the leaves were loosely painted with rather pale washes of Hooker's Green to which I added Lemon Yellow and/or French Ultramarine here and there. The unpainted outlines of some of the seedpods and buds now stood out clearly.

This procedure allowed me the freedom to produce a variety of compositions. Using master drawings the artist can build up complex designs, change colour schemes or combine a subject such as foxgloves with other woodland flowers.

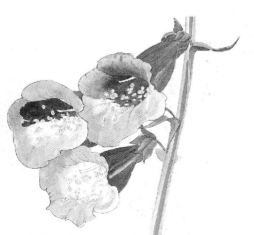

▲ *Fourth stage*

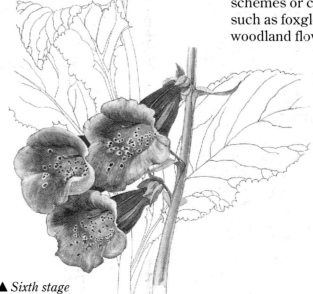

▲ *Sixth stage*

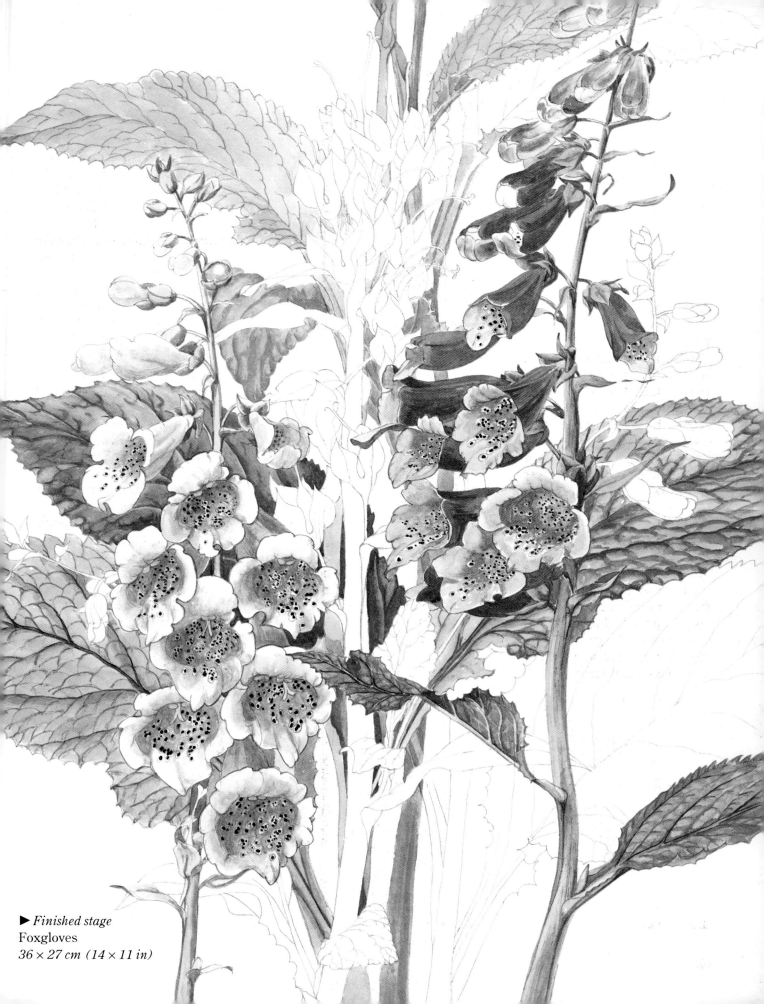

▶ *Finished stage*
Foxgloves
36 × 27 cm (14 × 11 in)

◄ Narcissus
27 × 21.5 cm (10½ × 8½ in)

In this painting of Narcissus flowers the strategic placing of some flowers with deep orange trumpets enlivens what could be a rather weak colour scheme.

Leaves can be painted in during the final stage as required to balance the composition. These flowers never fail to lift the spirit at the end of winter.